IMAGES
of America

MONTEREY COUNTY'S
NORTH COAST
AND COASTAL VALLEYS

D1615971

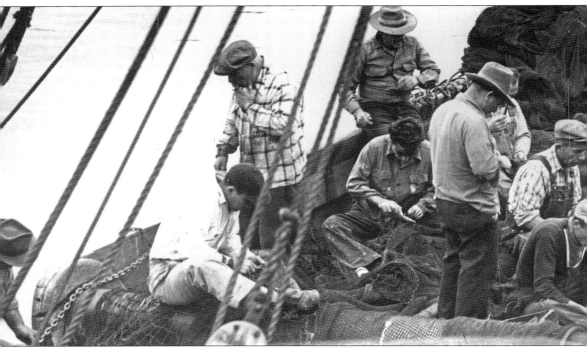

Fishermen repair their nets in Moss Landing. (Courtesy of the Monterey County Historical Society.)

IMAGES
of America

MONTEREY COUNTY'S
NORTH COAST
AND COASTAL VALLEYS

Margaret Clovis

ARCADIA
PUBLISHING

Published by Arcadia Publishing
Charleston SC, Chicago IL, Portsmouth NH, San Francisco CA

Printed in the United States of America

Library of Congress Catalog Card Number: 2006928522

For all general information contact Arcadia Publishing at:
Telephone 843-853-2070
Fax 843-853-0044
E-mail sales@arcadiapublishing.com
For customer service and orders:
Toll-Free 1-888-313-2665

Visit us on the Internet at www.arcadiapublishing.com

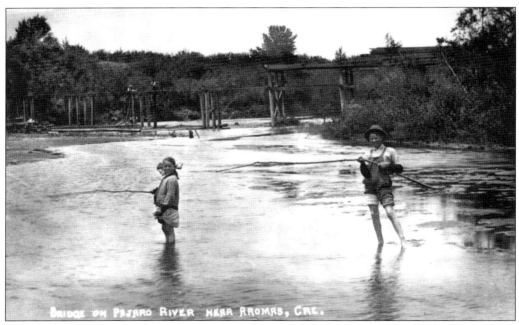

Two children try their luck with homemade fishing poles in the Pajaro River. In the background, the Aromas Bridge is being reconstructed after being washed away by floodwaters. (Courtesy of the Monterey County Library, Aromas Branch.)

CONTENTS

ACKNOWLEDGMENTS

This book was sponsored by the Monterey County Historical Advisory Commission, which is dedicated to educating the public about Monterey County's vibrant heritage. Several repositories contributed to the collection of photographs in this book. I wish to thank Pat Hathaway from the California Views collection; Dennis Copeland from the California History Room, Monterey Public Library; Julie Holland from the Monterey County Library, Aromas Branch; Mona Gudgel from the Monterey County Historical Society; Eric Van Dyke from the Elkhorn Slough National Estuarine Research Reserve; Regan Huerta and Jane Borg from the Pajaro Valley Historical Association; and La Scuola Restaurant in Castroville, who maintain the Castroville Historical Society's collection. In addition, I wish to thank individuals who shared their private collections, remembrances, and historical information, including Nancy Ausonio, Don Wolf, and Anna Cortapassi.

Special thanks to John Castagna for his expertise in scanning the photographs and bringing out the best in each one. Finally I wish to thank Lynn Learch and Christine Raarup for typing the manuscript and organizing the photographs.

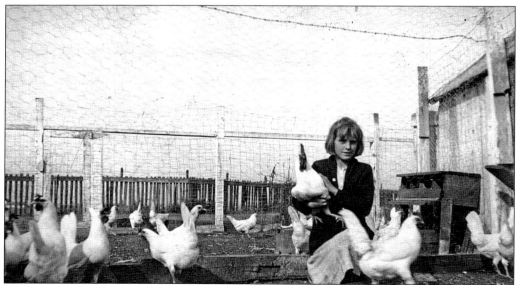

Pajaro Poultry Club winner Irene Davis shows off her flock of chickens. Irene purchased 50 day-old chicks, lost 5 chicks, sold 20 cockerels, and still had 24 pullets and a cockerel. She made a profit of $23.28. (Courtesy of the Monterey County Agricultural and Rural Life Museum.)

INTRODUCTION

As the fog recedes from Monterey County's north coast, a landscape of gentle hills, fertile valleys, and fields of rich soil is revealed. Several sloughs and the Pajaro River bisect the land as they meander to the ocean. Originally the area was populated by abundant wildlife, attracting the Ohlone people who could live off the cornucopia offered by land and sea.

Later Monterey Presidio families used the land to run their wild, longhorn cattle. Eventually the Mexican government would officially grant thousands of acres to the Castros, Sotos, Vallejos, and Anzars. As early as 1850, American settlers discovered this land of mists, building homesteads and turning the deep, dark soil. Juan Bautista Castro was the first to successfully establish a community when he subdivided his rancho into town lots. Next came Charles Moss, who recognized the natural advantages of the coastline for loading ships. The harbor he established would take his name. A few miles north, the town of Pajaro was taking shape, furthered by the arrival of the Southern Pacific Railroad in 1871. Less than 20 years later, John Porter would welcome onto his property refugees from Watsonville's ousted Chinatown. The Chinese now had a safe haven to operate their businesses and raise their families, and their community, known as Brooklyn, would eventually grow into one of California's largest Chinatowns. As settlers pushed into the coastal valleys they bought up parcels subdivided from the Anzar's Rancho Aromitas y Aqua Caliente. At the close of the 19th century, the village of Aromas would be described as an "up-to-date place."

A variety of industries supported those who lived in the north coast region. First and foremost was agriculture. Initially the evolution of crops mirrored the neighboring Salinas Valley, with grain cultivation leading the way. When sugar baron Claus Spreckels built a factory in nearby Watsonville, farmers turned to sugar beets. Then each region found its own niche. The Pajaro Valley became famous for its apple, berry, and lettuce crops. Aromas farmers found that apricots thrived in their sunny orchards. Castroville's foggy mornings were perfect for exotic artichokes, so much so that the community could claim the title "Artichoke Capital of the World."

Before the railroad arrived, Moss Landing provided the only shipping outlet for farmers from both the Salinas and Pajaro Valleys. In time, Captain Moss's harbor was opened to fishing and canning operations, including whales, sardines, and sharks. The Vierra family's nearby saltworks provided their product to the cannery operations.

The 1906 earthquake rocked the Central Coast but led to the expansion of the Logan Quarry in the Aromas hills. Much of the granite hammered from the earth went to rebuild San Francisco and surrounding communities.

Northern Monterey County's legend and lore is reflected in the photographs found in these pages. Those who settled here, who worked in the fields, and played at the shore would surely recognize their home in the description of one observer, who noted that northern Monterey County is "as beautiful as a poet's dream."

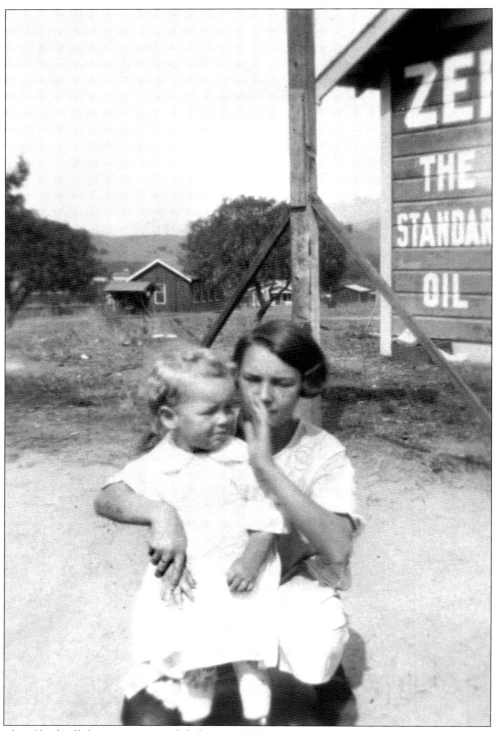

Evelyn Chadwell shares a secret with baby Harold (Pete) Martin near the service station on Blohm Avenue in Aromas. (Courtesy of the Monterey County Library, Aromas Branch.)

One

CASTROVILLE

In 1863, Juan B. Castro laid out the town of Castroville on the southwest portion of Rancho Bolsa Nueva y Moro Cojo. Lots were 50 by 130 feet, and an alley ran through each block. In order to lure residents, Castro donated land for public use and established a lottery to give 100 lots away. In April 1870, the *Castroville Argus* announced, "We will give alternate lots, on any part of the town site we still own . . . to any person who will build as soon as practicable, a good comfortable dwelling-house on his lot." (Courtesy of the Monterey County Historical Society.)

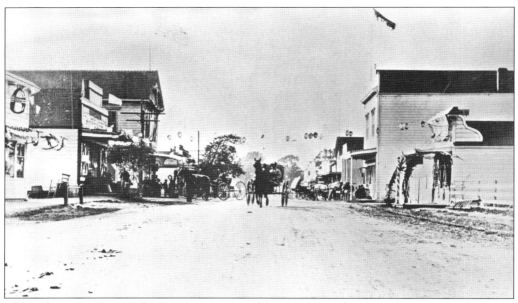

This early view of Castroville captures Merritt and Preston Streets looking west. By 1875, Castroville had a full compliment of businesses along Merritt Street to serve its 900 residents. These included "two good hotels, two livery stables, five stores, one tin shop, one millinery shop, three saloons, one brewery, one flour mill, two blacksmith shops, one newspaper, post office, telegraph offices, drug store, tailor shop, shoe-maker, two churches and a fine school house." (Courtesy of the Monterey County Historical Society.)

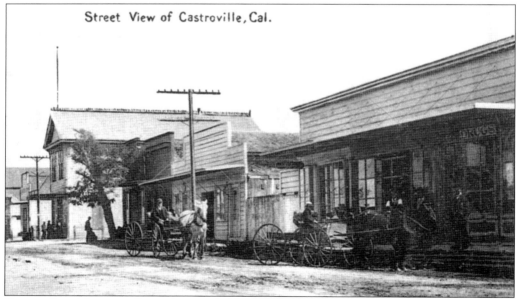

Castroville is Monterey County's second oldest town. Wooden sidewalks fronted early businesses along Merritt Street, and in 1885, the thriving town was described as "fully awake, and her citizens are discussing improvements that will rebound to the credit of the town." The two-story American Hotel, run by Mrs. A. Carroll, stands in the background. Customers could rent a room for $1 a day and have a meal for 25¢. (Courtesy of Pat Hathaway, California Views.)

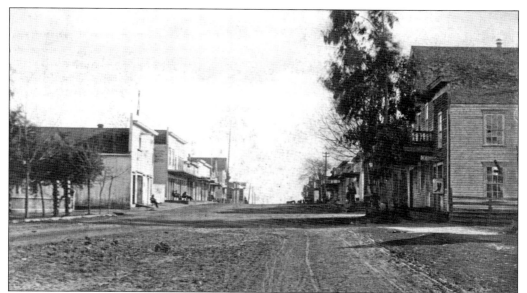

An 1886 view of Merritt Street shows Castroville residents relaxing in front of the many businesses that lined the road. In 1880, Joseph Merritt, editor of the *Castroville Argus*, wrote that visitors to the town would see, "signs of life, business and thrift . . . substantial stores and residences, pretty gardens and plenty of trees . . . we may well call Castroville a charming little town." The boot sign in the right foreground advertises shoemaker C. Conrad's business. (Courtesy of the Monterey County Historical Society.)

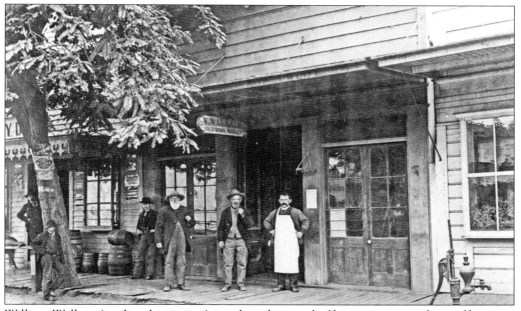

William Wallace (in the white apron) stands with several of his customers in front of his meat market around 1892. Wallace advertised, "the best fresh and salt meats, sausages, etc. on hand at the most reasonable prices." Wallace owned the shop until 1913 when he moved with his family to Salinas. Next door was Bambach's Tonsorial Parlor, where gentlemen could get a shampoo, haircut, and shave. (Courtesy of the Monterey County Historical Society.)

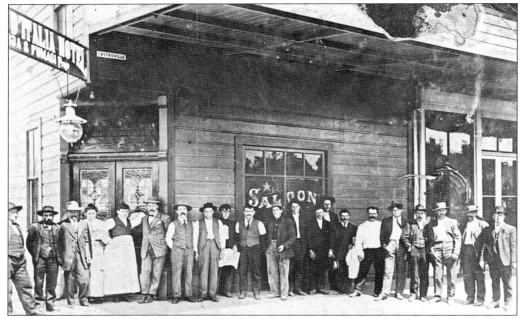

Patrons of the D'Italia Hotel's saloon pose for a photograph. There were unofficial saloons in Castroville as well. Cato Phillips remembers, "Every grocery store in town had a saloon in the back room. That's the way those guys made their money. I know, because I worked in stores. And I had to come in at 6 o'clock every morning to clean up and empty the spittoons." (Courtesy of Nancy Ausonio.)

Manuel R. Merritt learned the newspaper trade when he worked at the Monterey *Republican*. He later became editor of the Castroville *Argus*. He opened a mercantile business in town in 1878, later served as a notary public and as deputy sheriff, and in 1882 he was elected to the board of supervisors, representing the first district. Castroville's Main Street is named for him. (Courtesy of the Monterey County Parks Department.)

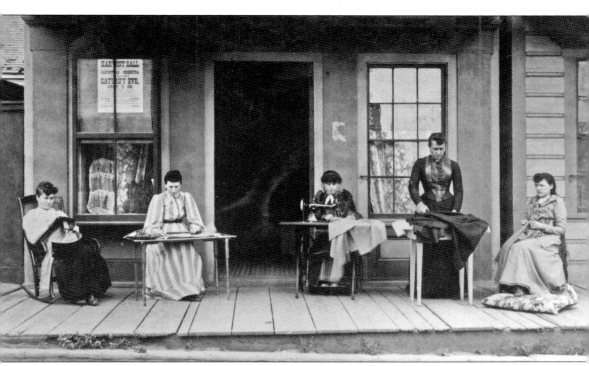

Five seamstresses are pictured in front of their shop on Castroville's Merritt Street in 1892. Maggie Vaughn Anderson is seated on the far right. A poster advertising the upcoming Harvest Ball is posted in their shop window. (Courtesy of the Monterey County Historical Society.)

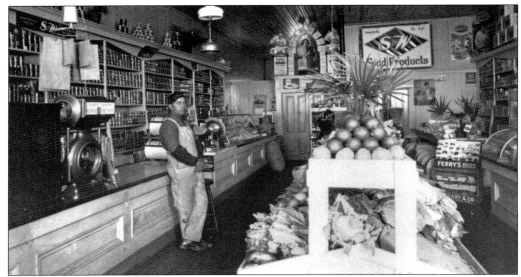

McCarthy's Hardware store stocked much more than nuts and bolts, as evidenced by the fresh produce and canned goods seen in this photograph. The store building was originally Castroville's public school, located on Preston Street between Seymour Street and Haight. Declared surplus property by the school district in 1902, the McCarthys rolled the building four blocks to the corner of Preston and Merritt Streets using logs and horse power. A harness store operated out of the back of the building. Today L'Scuola restaurant is located in the historic building. (Courtesy of the Castroville Historical Society.)

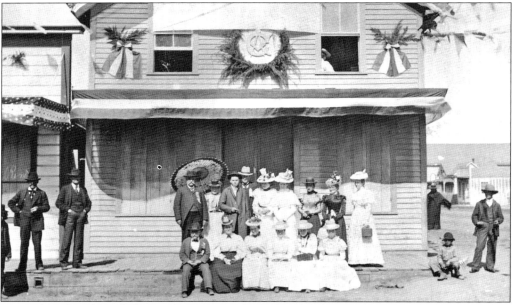

Dressed in their best, ladies and gents pose for a photograph in front of Castroville's Masonic Temple on September 9, 1897. They were gathered for a huge celebration of the Native Daughters and Sons of the Golden West for California's 47th birthday. Castroville had a full complement of benevolent organizations including Masons, Modern Woodmen of America, Odd Fellows, and the Young Men's Institute. (Courtesy of the Castroville Historical Society.)

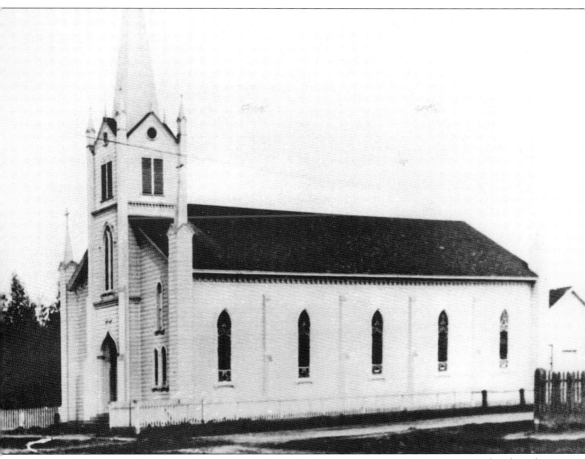

Castroville's beautiful Catholic church, with its high spire, was once a prominent landmark until it was destroyed by fire in 1959. Known as Our Lady of Refuge Church, it was formed in May 1869 when a priest from Watsonville celebrated Mass in a small chapel built in 1865. Ten years later, the stately church was built, incorporating the chapel as the sacristy. (Courtesy of Nancy Ausonio.)

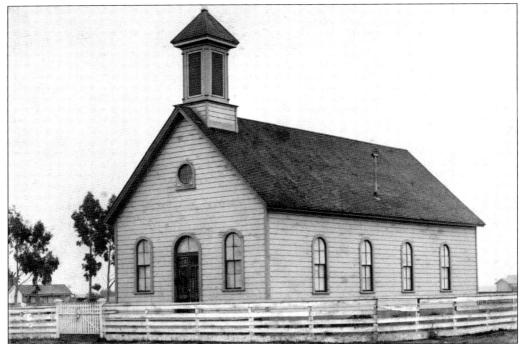

In 1880, Castroville's Union Church served "all Protestant denominations." The newspaper reported, "There is no resident Protestant clergyman, but a sermon is preached nearly every Sunday by one minister or another from Salinas. The Reverend George McCormick, Presbyterian; the Reverend J. S. McGowan, Episcopalian and the Reverend A. S. Gibbons of the M. E. Church, have preached here frequently during the past few years." (Courtesy of the Monterey County Historical Society.)

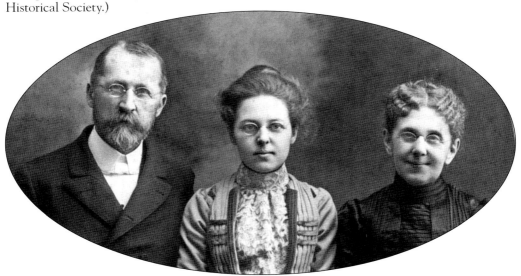

Two churches, one Catholic and one Protestant, served the spiritual needs of the Castroville community. At the Union Church, Rev. George McCormick, pictured here with his family, led a Sunday service at 3:30 p.m. and Sunday school at 2:30 p.m. (Courtesy of the Monterey County Historical Society.)

In 1874, Missouri native Dr. John Parker moved to this house in Castroville, beginning a long line of Parkers practicing medicine in Monterey County. On the day he arrived, he treated his first patient for a gunshot wound, the victim of a street shoot-out. The doctor charged $25 for the home delivery of a baby and $2.50 for house calls. (Courtesy of the Monterey County Historical Society.)

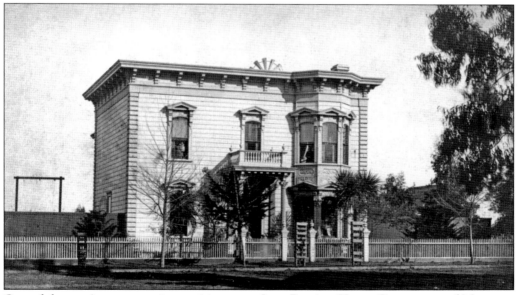

One of the area's most prominent citizens was Juan Bautista Henry Cooper, son of Monterey pioneer Capt. John Cooper. J. B. H. Cooper inherited 17,000 acres of his family's Rancho Bolsa del Portrero. Cooper married in 1871 and soon after built this house on the corner of Merritt and Speegle Streets, surrounded by formal gardens. The home was considered one of the grandest in Monterey County. (Courtesy of the Monterey County Historical Society.)

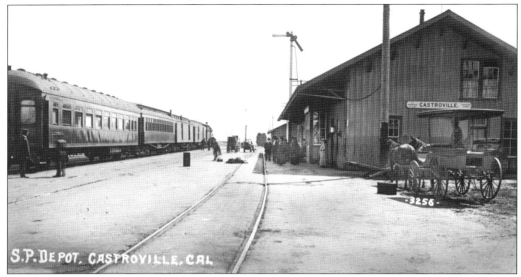

When the Southern Pacific Railroad began extending its line south from Gilroy in 1871, Juan B. Castro had hoped Castroville would become the main terminus for the Salinas Valley. The railroad chose Salinas over Castroville since Castro's asking price for land was too high. However, Castroville was still considered an important stop, as it served as "the point of juncture of the road from Monterey and that from Soledad to San Francisco." In addition, Southern Pacific built the region's first roundhouse at the depot. Notice the carryall on the right. Drawn by two well-groomed horses, it met passengers at the depot. (Courtesy of Pat Hathaway, California Views.)

Castroville was a 20-minute stop on the Southern Pacific line. To accommodate travelers, the company built a small park on the north side of the depot. Across the street was the two-story St. James Hotel, operated by the James Murphy family. Lodging could be had for $1.50 to $2 per night, with special rates for regulars. Several saloons accommodated thirsty passengers. (Courtesy of Pat Hathaway, California Views.)

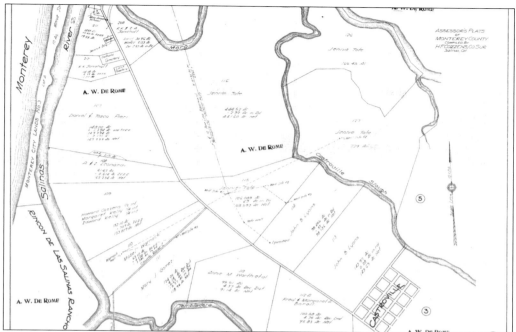

Early on, the area around Castroville was crisscrossed by a network of sloughs and surrounded by swamp land. The area was known as the Tembladera, which in Spanish means trembling earth. In the 1840s, mapmaker Duflot de Mofras wrote, "A few leagues before reaching the Pajaro River, an area measuring a few hundred meters where the ground trembles under the horses feet, although the earth is hard and covered by turf, is encountered. This place, known as La Tembladera, is probably formed by a solid crust superimposed on a vast miry base." (Courtesy of the Monterey Public Library, California History Room Archives.)

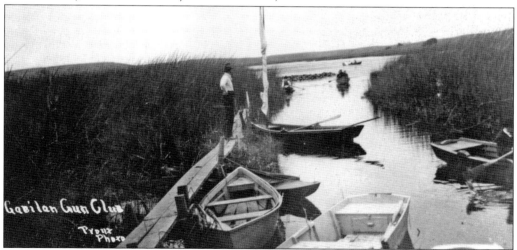

The Castroville area was popular for hunters from as far away as San Francisco. An 1889 account noted, "The lakes and sloughs of the immediate vicinity are covered with wild ducks during certain seasons of the year and the marsh land is fine snipe ground." In 1905, the Gabilan Gun Club was built at Lake Merritt near Castroville. At the time, 50 mallard ducks were considered a day's limit. (Courtesy of the Monterey County Historical Society.)

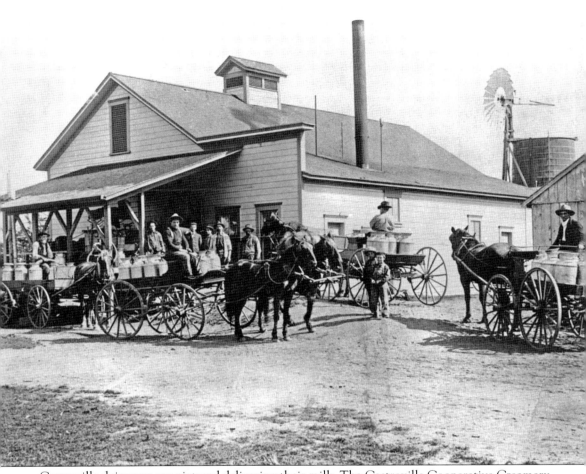

Castroville dairymen are pictured delivering their milk. The Castroville Cooperative Creamery was established in 1897; it was Monterey County's oldest creamery. Milk was processed into cheese and butter and shipped to California markets. The by-products, whey and buttermilk, were used by dairymen to feed their hogs and calves. Prior to World War II, the Royal Creamery took over the company before moving to Salinas. The business was later sold to the Golden State Milk Company and then to the Foremost Company. (Courtesy of the Monterey County Historical Society.)

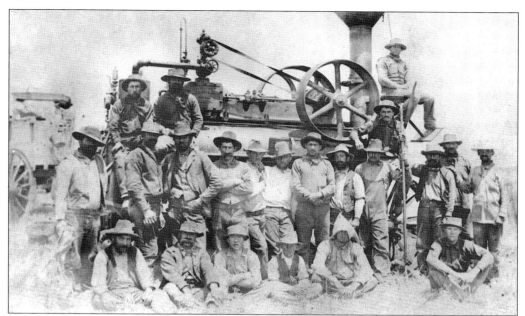

A harvesting crew on Blackie Road poses in front of a steam boiler used to power threshing machines. After grain was cut by a header, it was tied into bundles up to nine feet long, loaded on to wagons, and hauled to a stationary thresher in the field. A 30-foot belt connected the boiler to the thresher. (Courtesy of Nancy Ausonio.)

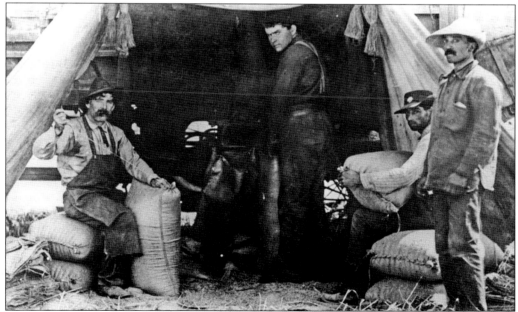

In 1888, the *Monterey Democrat* described a harvesting scene where "at the side, protected from the dust and chaff by a canvas awning, a steady stream of clear, ripe grain is received into new sacks by one man, while another deftly stitches up the mouth of each, as filled, and with marvelous dexterity carries it out and deposits it upon a fast-increasing pile." Sack sewers, pictured here on Blackie Road, sewed on average 1,100 sacks per day. (Courtesy of Nancy Ausonio.)

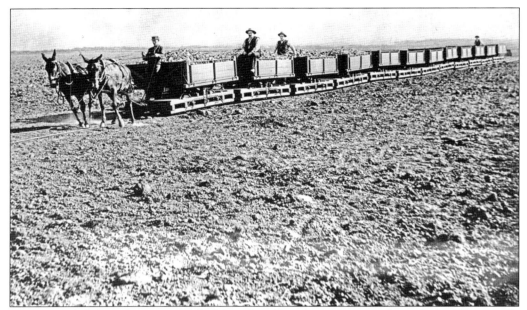

Claus Spreckels leased portions of the Moro Cojo Ranch to grow sugar beets for his Watsonville sugar factory. To facilitate the transport of the beets from the field to the railroad, a portable track was used, as seen in this photograph. Mules pulled beet cars along the track that could be assembled as needed using predrilled curved and straight sections. (Courtesy of the Pajaro Valley Historical Association.)

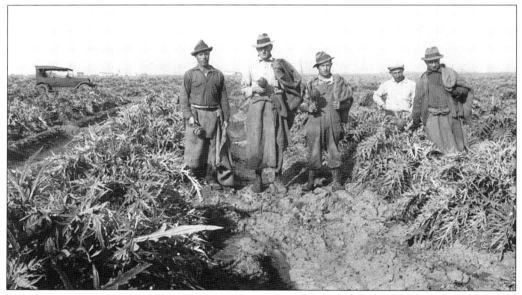

Artichoke pickers pose in a field outside of Castroville. Andrew Molera is credited with introducing artichokes to the Central Coast. When faced with the loss of longtime tenant Claus Spreckels, Molera looked for alternative crops to fill the void. He obtained some artichoke shoots from Half Moon Bay and planted an acre near the entrance to his Mulligan Hill ranch on Molera Road. In 1922, Angelo Del Chiaro and Egidio Maracci inquired about the artichokes and subsequently leased 150 acres from Molera for an artichoke crop. (Courtesy of Nancy Ausonio.)

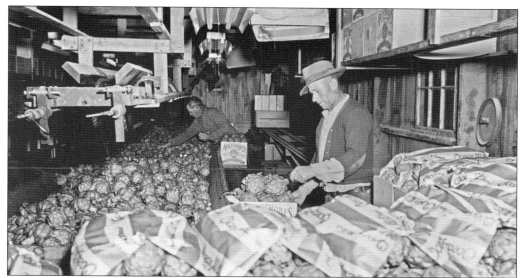

Daniel Pieri and cousins Amerigo and Angelo Del Chiaro planted 150 acres of artichokes in 1922. Their success prompted others to take notice, and by 1923, there were nine growers. This number grew to 50 just four years later when almost 12,000 acres of artichokes were cultivated in the Monterey Bay area. Artichokes were packed in sheds. First they were sorted by size and quantity and then packed in light wooden boxes. Each box contained between four and 10 dozen artichokes. A full box, on average, weighed 43 pounds. Here artichokes are readied for shipment from the Ocean Mist packing shed. (Courtesy of Nancy Ausonio.)

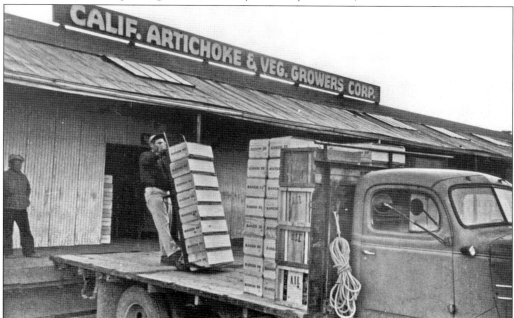

In 1924, the Pieri, Del Chiaro, Tottino, and Bellone families formed the California Artichoke and Vegetable Growers Corporation in order to market and ship their artichokes. Today it is recognized as one of the largest artichoke operations in the country. In this photograph, Hugo Tottino loads a truck with artichokes ready for shipment. (Courtesy of the Castroville Historical Society.)

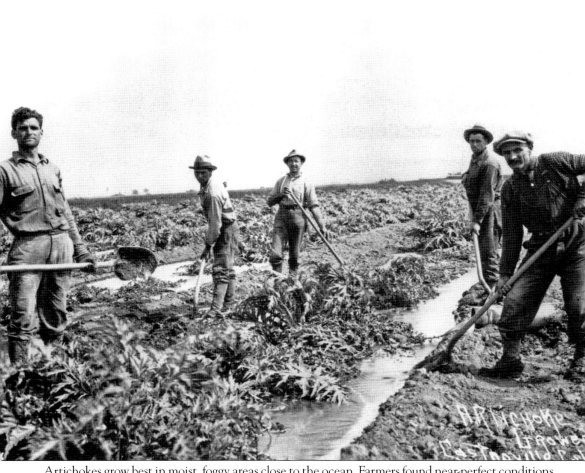

Artichokes grow best in moist, foggy areas close to the ocean. Farmers found near-perfect conditions in Castroville. Growers are busy in the summer months trimming plants, irrigating, as seen here, and fertilizing. Between August and May, artichokes are hand harvested. (Courtesy of the Castroville Historical Society.)

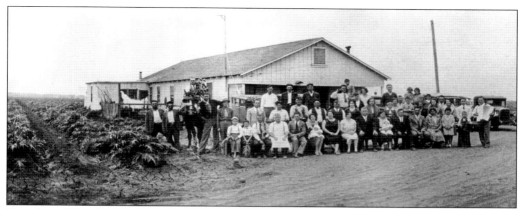

Friends and family joined the Ausonios for their son Andy's christening day at the Mulligan Hill artichoke ranch were he was born. After serving in the Korean War, Andy returned to Castroville and established Ausonio Construction, Incorporated, one of the leading building contractors in the Salinas Valley. (Courtesy of Nancy Ausonio.)

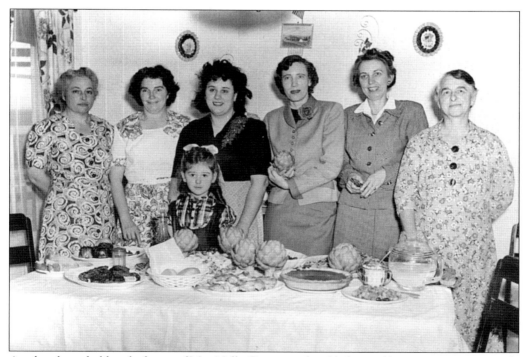

At a luncheon held at the home of Mrs. Nello Cagniacci, local ladies and home economists sample a variety of artichoke dishes. Pictured, from left to right, are Mrs. P. Mugnaini; Mrs. A. Micheletti; the hostess with her daughter Diane; Ruth Bateman, a "food stylist" from San Francisco; Anne Olson, county home economist; and Mrs. L. Grassetto. (Courtesy of Nancy Ausonio.)

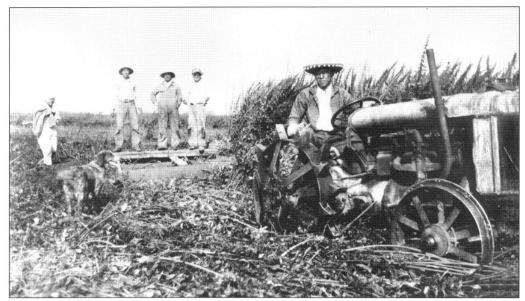

Japanese workers take a break from clearing a field outside of Castroville. In the 1890s, Japanese immigrants worked as seasonal laborers. From laborers, they evolved into sharecroppers and then into lease holders. Often the properties were reclamation leases, whereby in exchange for clearing land and bringing it into production, the lessee could use the land at no charge for five years. (Courtesy of Don Wolf.)

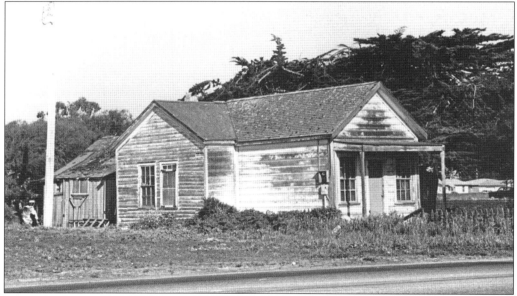

Pictured is Castroville's first school, a converted butcher shop, located on the block north of Speegle Street. This building was soon replaced by a new one-room schoolhouse on the east side of town. In 1927, when a new grammar school was dedicated, Mrs. Charles Whitcher gave an "instructive address" regarding the history of Castroville schools. She noted, "In this room for a goodly number of years, the youth of Castroville took their first trembling steps on the strenuous road to learning." This building was later moved to Moss Landing. (Courtesy of Nancy Ausonio.)

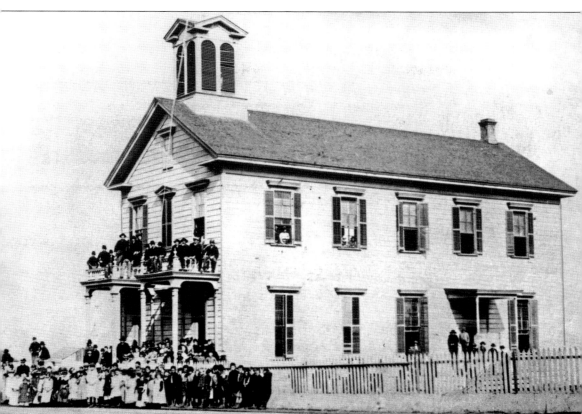

As she took Castroville residents down memory lane, Mrs. Charles Whitcher related, "In 1873 the citizens of Castroville taxed themselves by an almost unanimous vote to the amount of $3,500 to build another school building to house the increasing number of children." The new two-story school was located on the corner of Preston and Seymour Streets. The building was later moved to the corner of Preston and Merritt Streets for use as a hardware store and today serves as a restaurant. (Courtesy of Nancy Ausonio.)

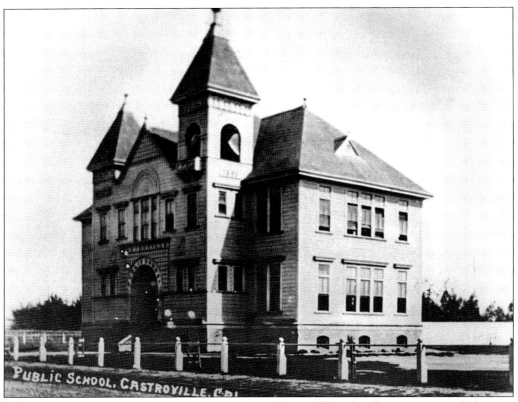

PUBLIC SCHOOL, CASTROVILLE, CAL.

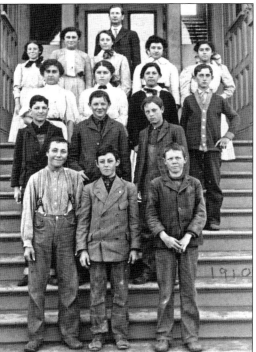

Castroville's schoolhouse was crowded with up to 70 pupils in one room. In 1895, citizens voted to build a six-room, $16,000 schoolhouse. The new building was located in the block bounded by McDougall, Salinas, and Pomber Streets. It was noted that "the teachers of that day felt they had indeed entered into possession of a school mansion. In beauty and size and utility it far exceeded the building vacated. The whole community was filled with pride in their new school." (Courtesy of Nancy Ausonio.)

The class of 1910 poses on the steps of Castroville's school. Pictured with principal Septha Ginn, from left to right, are (first row) Tony Ferrari, unidentified, and unidentified; (second row) Ray Castro, Rudolph Westfall, and Everett Hare; (third row) Mamie Leal, May Hurley, Mamie Gomes, and George Wallace; (fourth row) Alta Lyons, Bernice McIntyre, Bell T. Ferrari, Nettie Castro, and Nettie Leal. (Courtesy of the Monterey County Historical Society.)

Safety first! The Castroville School District opted to build a fire escape slide from the second floor rather than a conventional fire escape. No doubt children looked forward to fire drills as they gleefully slid from a second floor window to the ground. (Courtesy of Nancy Ausonio.)

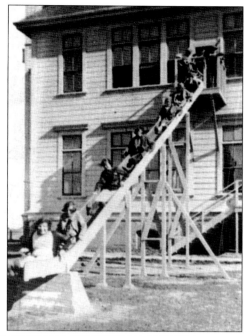

Amidst great fanfare, Castroville's new $75,000 grammar school, designed by William Weeks, was dedicated in May 1927. The Native Sons of Castroville opened the program followed by a children's choir and a maypole performance accompanied by the U. S. 11th Calvary Band. Guests were treated to a barbeque, and that evening, a dance was held in the new school. To the lively tunes of Rowling's Orchestra, merrymakers lit up the dance floor with the polka, schottische, and rye waltz. (Courtesy of Nancy Ausonio.)

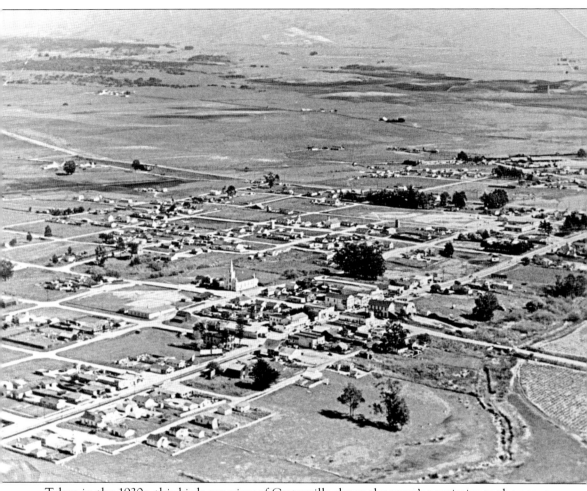

Taken in the 1930s, this birds-eye view of Castroville shows the town's proximity to the ocean. At the time, the area was described as a center for dairying, fruit crops, and the Burbank potato. (Courtesy of Nancy Ausonio.)

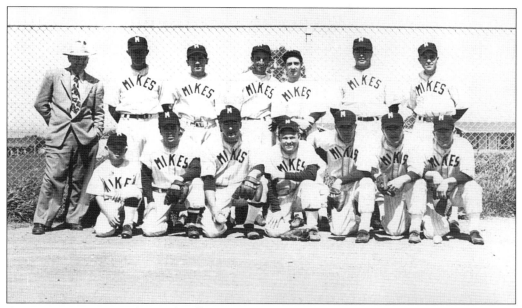

America's pastime was alive and well in Castroville. Besides this team, sponsored by Mike's Bar, the Cal Chokes and Padres kept residents cheering. (Courtesy of Nancy Ausonio.)

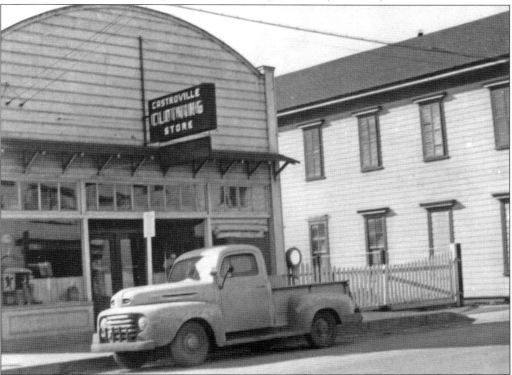

The Castroville Clothing Store was originally the George Grocery, owned by Arthur George. Later it became the Roberti Plumbing and Tinsmith Shop. Anna Roberti Cortapassi remembers living in the back of the store when she was a baby. (Courtesy of the Castroville Historical Society.)

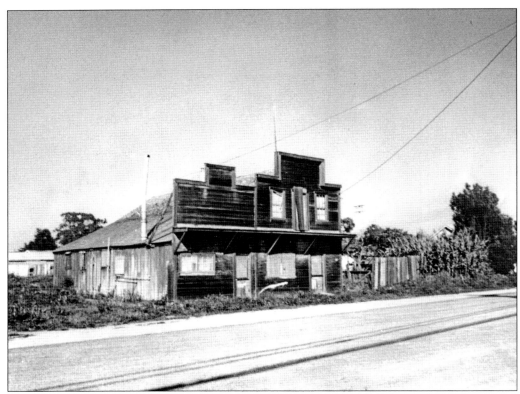

Pictured is one of the last buildings associated with Castroville's block-long Chinatown. It was located on McDougall Street between Speegle Street and Sanchez. Chinese laborers worked in the surrounding beet, potato, and grain fields. John Hayes remembers, "At 5:00 in the afternoons approximately 125 to 150 Chinese could be seen on the streets coming home from work." (Courtesy of Nancy Ausonio.)

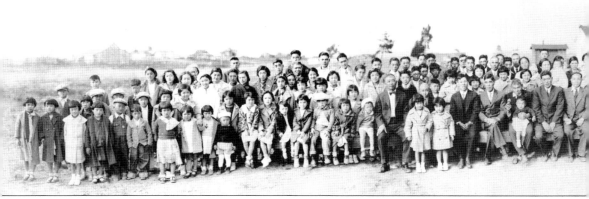

Castroville's Japanese school was dedicated on August 31, 1936. Approximately 20 Japanese families lived in Castroville at that time. In order to teach their children about Japanese traditions and culture, parents built a Japanese school on the corner of Geil and Pajaro Streets. Children

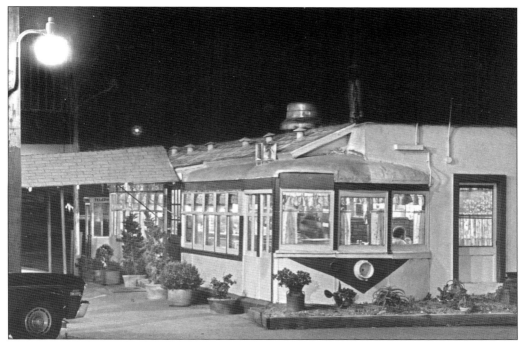

Bing's Diner has been serving rib-sticking barbeque since 1943. The diner was originally a 900 Series trolley car built in the 1920s and used in Oakland. According to rumor, the name Bing's was adopted after a visit from Bing Crosby, who was passing through on his way to Pebble Beach. (Courtesy of the Pajaro Valley Historical Association.)

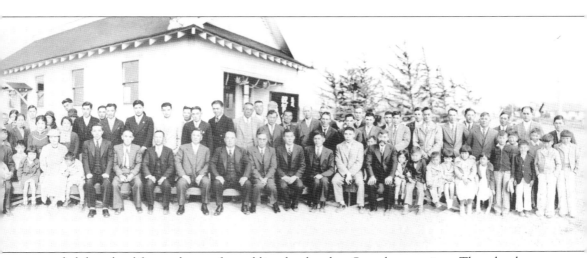

attended the school for two hours after public school and on Saturday mornings. The school was closed after the bombing of Pearl Harbor. Today it is listed on the National Register of Historic Places. (Courtesy of Janice Higashi.)

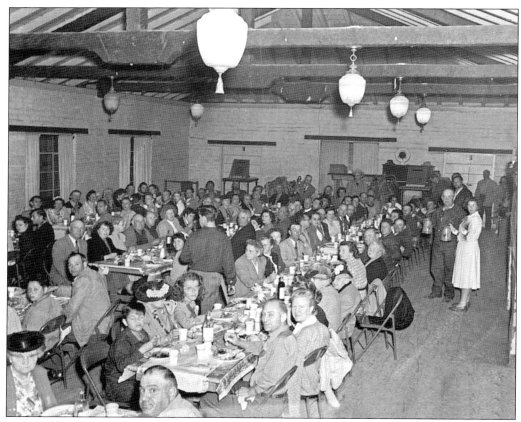

Castroville's Community Hall opened in 1940. It was funded by a Public Works Administration grant and built with Works Progress Administration labor. The Castroville Legionnaires operated the building, and it served as home to local Boy Scout troops. (Courtesy of Nancy Ausonio.)

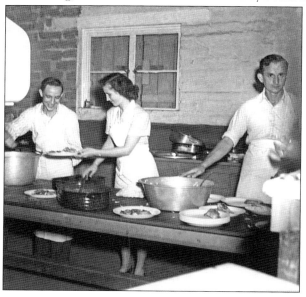

Cooks in the Community Hall kitchen prepare a ham dinner to celebrate the grand opening. Besides ham, they fixed 100 pounds of sweet potatoes for the 200 Castroville residents who attended. All the food was donated by local families and businesses. (Courtesy of Nancy Ausonio.)

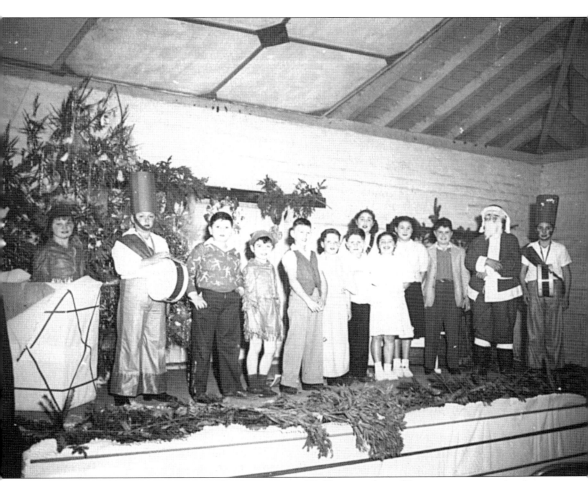

Castroville children join Santa on the Community Hall's stage for a Christmas pageant in the 1940s. (Courtesy of Nancy Ausonio.)

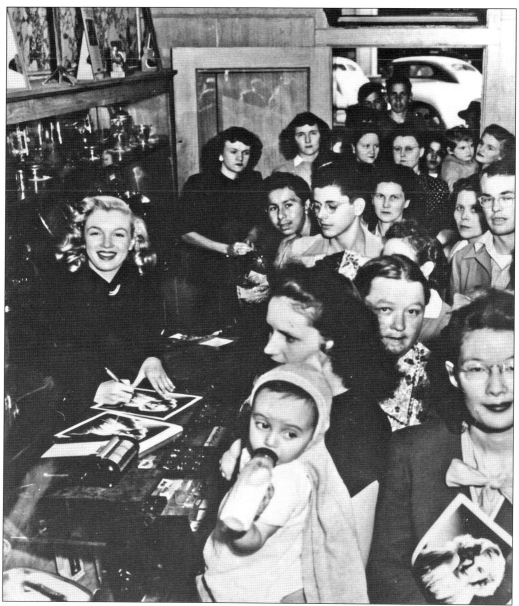

When starlet Marilyn Monroe visited Salinas on a promotional tour for diamonds, a couple of enterprising residents talked her into stopping by Castroville. Here she signs autographs for fans. In appreciation, they crowned her the honorary artichoke queen for 1948. (Courtesy of the Castroville Historical Society.)

Two

MOSS LANDING

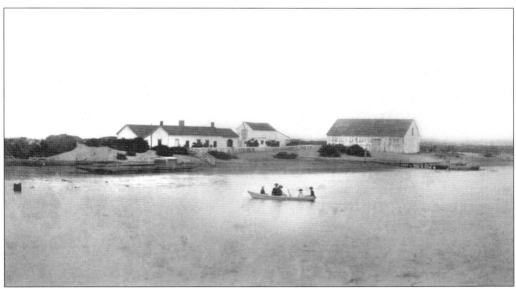

In 1866, retired seafarer Capt. Charles Moss moved his family from Texas and built the pictured homestead near what was to become Moss Landing. He and partner Donald Beadle built warehouses, a wharf, and other facilities to ship lumber, grain, and produce from the fertile Salinas and Pajaro Valleys. Three years later, the *Pajaronian* newspaper noted that Moss Landing was buzzing with activity and "during the season—in the fall—as many as 60 teams have congregated at the warehouses at a time." Always the entrepreneur, Moss sold his interests in the seaport to the Pacific Coast Steamship Company in 1876. (Courtesy of Pat Hathaway, California Views.)

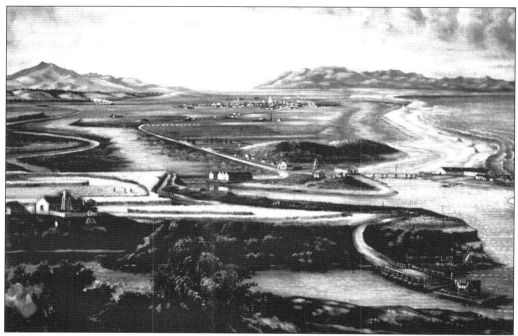

French artist Leon Trousset painted this bird's-eye view down the coast from the Elkhorn Slough. He arrived in San Francisco in 1877 and traveled to Moss Landing to visit with his relatives, the Vierras. Vierra's Ferry, Moss Landing warehouses, and distant Castroville are depicted in this charming painting. It now can be found in the rectory of Castroville's Our Lady of Refuge Parish. (Courtesy of Nancy Ausonio.)

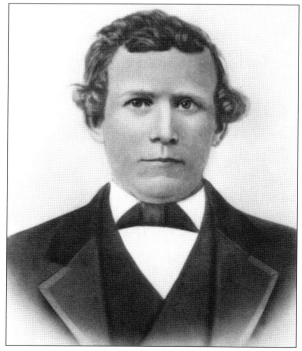

English native Joseph Truman Roadhouse bought property bordering the Elkhorn Slough in 1852. Here in a grove of live oaks, he built a ranch for his family, raising cattle and beautiful racehorses. Roadhouse is credited with naming the slough, inspired by its resemblance to the shape of an elk's horn. (Courtesy of the Elkhorn Slough National Estuarine Research Reserve Collection.)

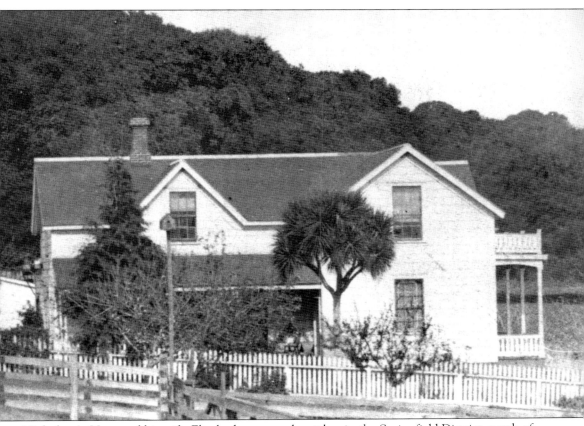

Nicholas A. Uren and his wife, Elizabeth, were early settlers in the Springfield District, north of Moss Landing. They settled here in the late 1850s, establishing a ranch and building this home. Their great granddaughter, Marguerite Hartman, remembers that "the milk house was behind this house to the left. It had channels in the floor for spring water to run through to keep the milk pans cold." (Courtesy of the Pajaro Valley Historical Association.)

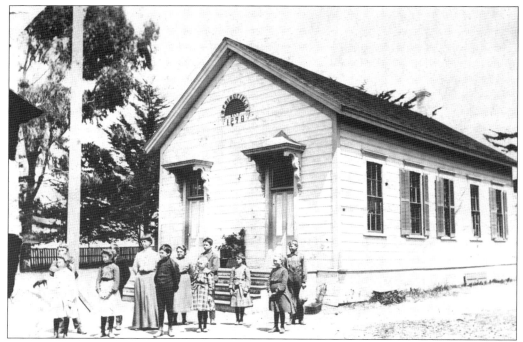

Teacher Lillian Gibson is surrounded by her students in front of the Springfield School. The school, as well as the surrounding area, was "so named for a spring in the field of John Smith." Built in 1878, the pretty Italianate schoolhouse served the area's children until it burned down in 1928. (Courtesy of the Pajaro Valley Historical Association.)

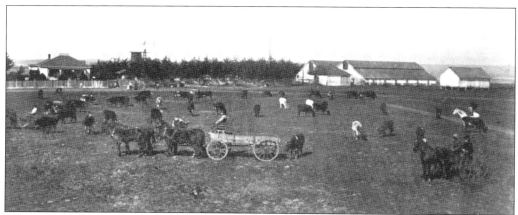

Pictured is the Cato Vierra ranch that spread over 1,000 acres of land in the vicinity of Moss Landing. Vierra settled here in 1867 when he became construction engineer for Captain Moss. Together they built Moss Landing into a central shipping point for the Pajaro and Salinas Valleys. Cato and his wife, Maria de Freitas, had 14 children who continued to live and work in the Moss Landing area. (Courtesy of the Elkhorn Slough National Estuarine Research Reserve Collection.)

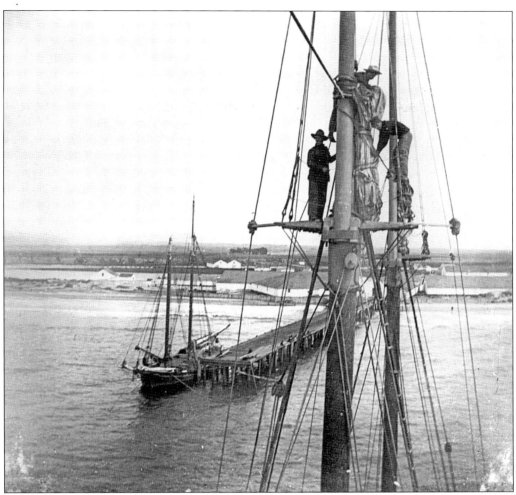

Sailors have a bird's-eye view of Moss Landing's warehouses while they work on a three-masted schooner. To get shipments to schooners waiting offshore, men had to wade through waist-deep surf while carrying 100-pound sacks of grain on their shoulders. Later more efficient surf boats ferried the grain until finally a 200-foot wharf was built where schooners could tie up to receive their cargo. (Courtesy of the Monterey County Historical Society.)

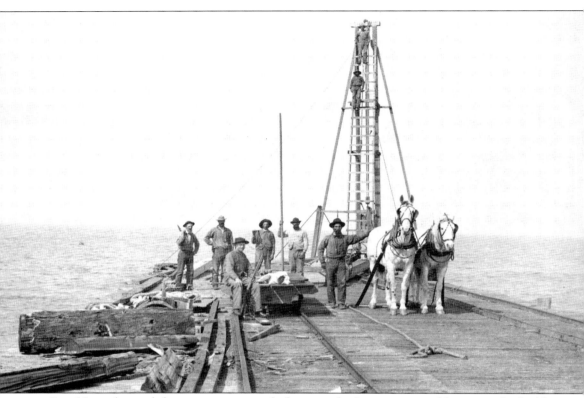

Cato Vierra learned the construction trade first as a ship's carpenter and later as a shipbuilder in his native Azores Islands. In 1867, he joined Captain Moss's seaport venture as construction engineer. He built the first pier into the surf, seen here, and the first bridge over Elkhorn Slough. His efforts eventually led to Moss Landing becoming a major shipping point with the ability to handle over 15,000 tons of grain. (Courtesy of the Elkhorn Slough National Estuarine Research Reserve Collection.)

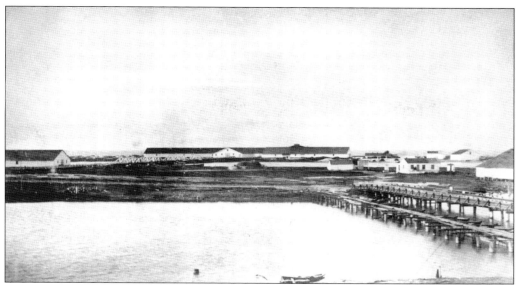

The first wharf at Moss Landing was weighted down with bags of sand to prevent it from washing away. Farmers recognized a golden opportunity to market their bountiful grain crops. Before long, 10-mule teams stretched for five miles from the warehouses, which were eventually expanded to store up to 15,000 tons of grain. Pictured are the warehouses and shipping facilities in 1891. (Courtesy of the Pajaro Valley Historical Association.)

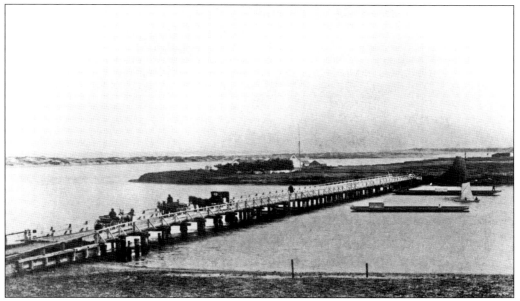

Pictured is Cato Vierra's toll bridge constructed in the early 1870s. Prior to that, he operated a ferry across the mouth of the Elkhorn Slough—part of the property he acquired from Frenchman Paul Lazere, who had hoped to establish the town of St. Paul. The Vierra home is visible on the point to the left of the bridge. Two lighters (flat-bottom boats) make their way up the slough to Gibson's Landing on the Salinas River, and Watsonville Landing (later known as Hudson's Landing). They carried grain, potatoes, and beans from inland farms to Moss Landing for shipment.

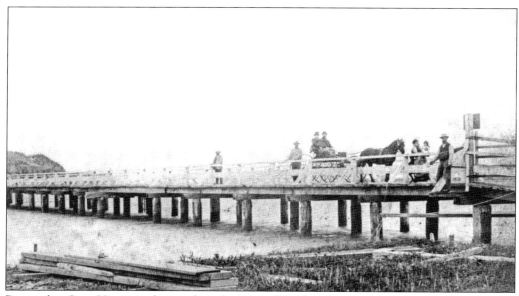

Pictured is Cato Vierra at the north end of his toll bridge about 1880. He operated the bridge until 1889, when he sold it to Monterey County for $4,250. (Courtesy of the Monterey County Historical Society.)

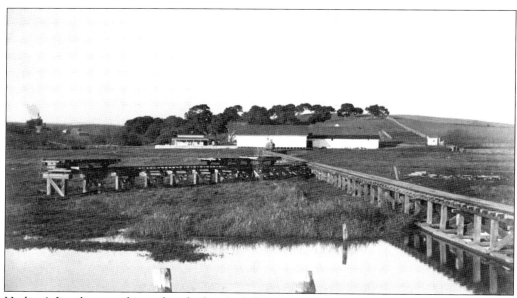

Hudson's Landing was located at the head of Elkhorn Slough and served as a shipping point for inland valleys. Originally it was known as Brennan's Landing for first owner James Brennan. It was later known as Watsonville Landing and then Hudson's Landing for Mark Hudson, who was named agent in 1868. He ran the operation for over 40 years for the Goodall, Nelson, and Perkins shipping line. Farmers from the Pajaro and Salinas Valleys shipped their grain from here, down Elkhorn Slough to waiting steamships at Moss Landing. (Courtesy of the Elkhorn Slough National Estuarine Research Reserve Collection.)

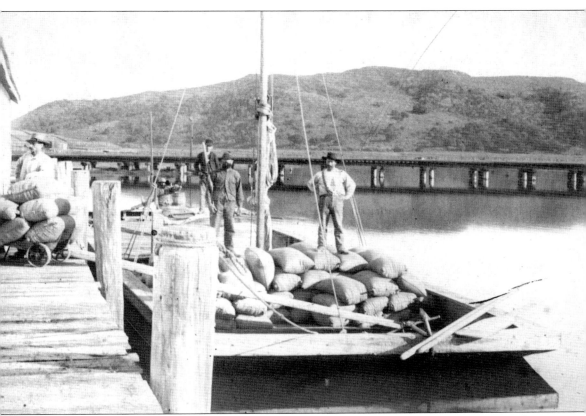

Stevedores at Hudson's Landing load bags of grain onto long "lighter" barges for the trip to the mouth of the Elkhorn Slough. One or two men would walk the lighter decks, digging poles into the muddy water to propel the barges. The tracks of the Pajaro Valley Consolidated Railway can be seen in the distance. Shipping traffic along the slough fell off after the beginning of the 19th century. (Courtesy of the Elkhorn Slough National Estuarine Research Reserve Collection.)

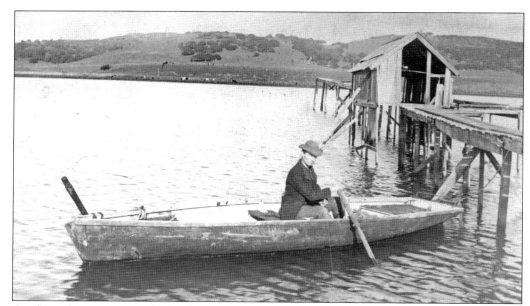

A solitary boater rows to the Hudson Landing pier. The first warehouses were constructed from Corralitos redwood, with wallboards and flooring measuring up to two feet wide. In 1914, E. C. Vierra, son of Cato Vierra, dismantled the buildings, salvaging 200,000 feet of lumber. (Courtesy of the Monterey County Historical Society.)

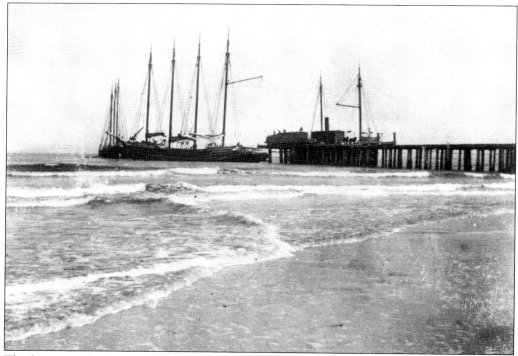

The four-masted schooner *Wild Rose*, three-masted schooner *Lilly and Mattie*, and steam freighter *Duncan* are loaded with lumber at the Moss Landing wharf. (Courtesy of the Monterey County Historical Society.)

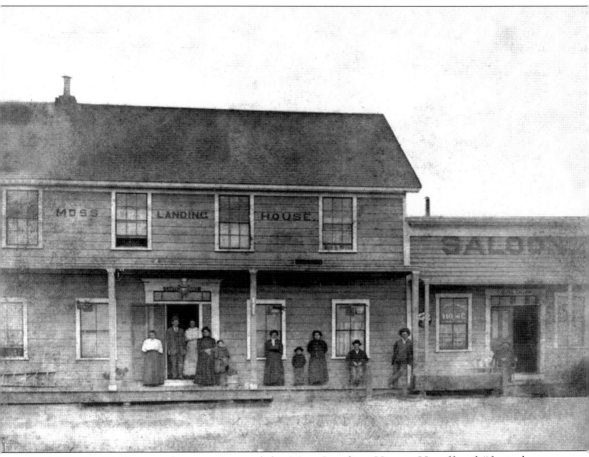

In 1893, G. Pfeffer was the proprietor of the Moss Landing House. He offered "first class accommodations for boarders by the day or week" and a special dinner on Sundays for 25¢. Excursionists and picnickers could rent fishing outfits and ammunition. Next door, the saloon sold the best brands of wines, liquors, and cigars. (Courtesy of Pat Hathaway, California Views.)

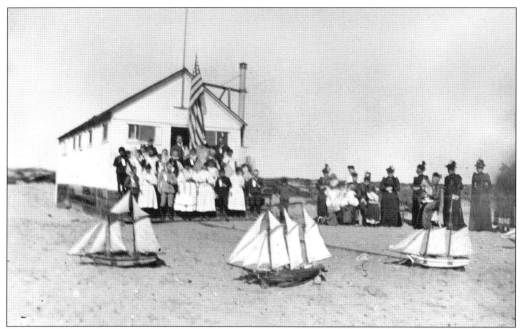

Pictured is Moss Landing's first school. During the 1860s, the river steamer *Brocero* plied the waters of Elkhorn Slough. Competition from the railroad forced the ship's retirement in 1874. Two years later, Moss Landing residents bought the *Brocero's* cabin, set it up on sand dunes north of the wharf, and transformed it into Moss Landing's school. A gable roof was added and decking from the *Brocero* was used for the floor. There was enough room for two rows of desks, each desk seating three students, with an aisle down the center. (Courtesy of the Elkhorn Slough National Estuarine Research Reserve Collection.)

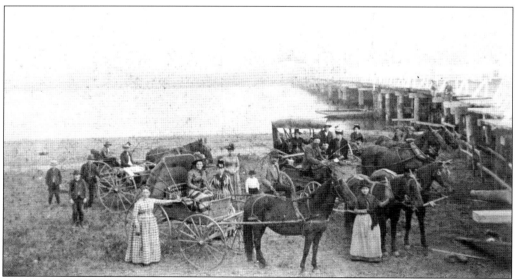

At the foot of Elkhorn Slough Bridge, picnickers pause for their photograph to be taken. Among those pictured are Mr. and Mrs. Jaspar Phares, Elizabeth Kalar, and Rebecca Bonnifield. (Courtesy of the Monterey County Historical Society.)

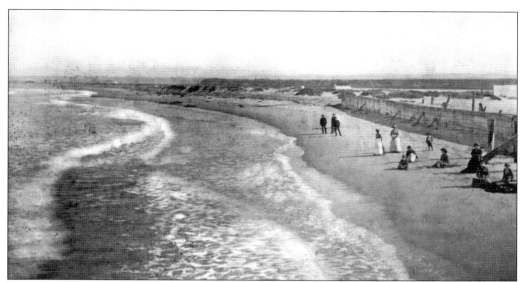

Moss Landing was a favorite Sunday destination for families from the surrounding area. In the 1870s, the steamship *Brocero* transported Watsonville residents to the landing for 50¢ a head. Twenty years later, it was still a venue for good times. Watsonville's California Hose Company No. 2 sponsored a May Day railroad excursion to Moss Landing for a picnic, "first class music," and dancing from 10:00 a.m. to 6:00 p.m. A baggage car was provided for lunch baskets and "everybody is expected to be present." (Courtesy of the Monterey County Historical Society.)

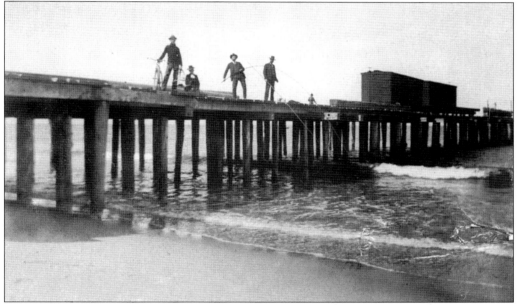

Anglers cast their lines into the surf from Moss Landing's wharf. E. S. Harrison, publisher of the 1889 souvenir edition of *Monterey County Illustrated: Resources, History, Biography*, wrote, "Moss Landing is rapidly growing into favor as a sea-side resort. Its beautiful beach, refreshing breezes, and facilities for bathing and fishing, as well as its conveniences for camping, render it an attractive resort to the inhabitants of the Salinas, Pajaro, and San Juan Valleys." (Courtesy of the Pajaro Valley Historical Association.)

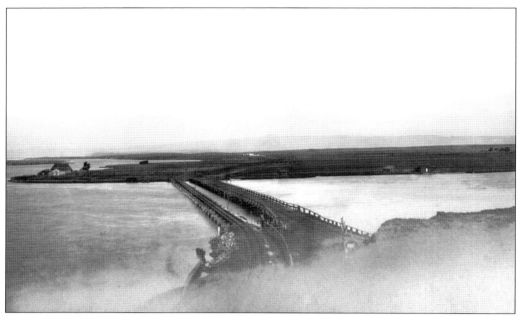

Pictured side by side are the county bridge crossing the Elkhorn Slough and the Pajaro Valley Consolidated Railroad trestle. To avoid high rates charged by the Southern Pacific Railroad, sugar king Claus Spreckels decided to build a narrow gauge to the steamship wharf at Moss Landing. By the summer of 1890, the railroad linked the Western Beet Sugar factory in Watsonville to the Pacific Coast Steamship Company in Moss Landing. (Courtesy of Pat Hathaway, California Views.)

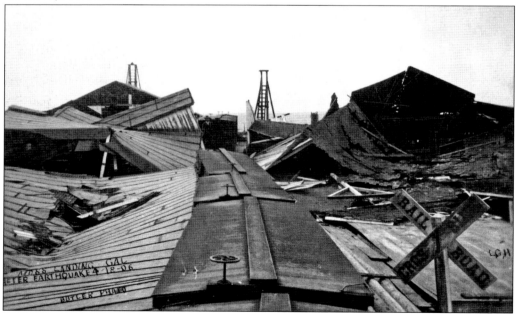

Moss Landing suffered extensive damage due to the 1906 earthquake that rocked the California coast. Half a dozen warehouses were leveled, train tracks twisted, and bridges collapsed. (Courtesy of Pat Hathaway, California Views.)

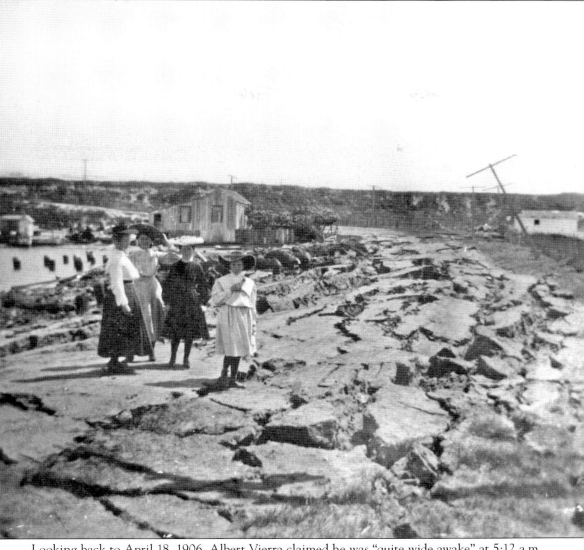

Looking back to April 18, 1906, Albert Vierra claimed he was "quite wide awake" at 5:12 a.m. He claimed that the earthquake gave Moss Landing "a good shaking, taking down warehouses, breaking bridges and the pier over the surf and opening a few deep fissures in the mud." Here three young girls view rows of deep cracks in the road. (Courtesy of the Monterey County Historical Society.)

In 1922, William Sandholt, former owner of the Monterey *Cypress-American*, purchased the holdings of the Pacific Coast Steamship Company at Moss Landing. His goal was to develop Moss Landing into a major harbor facility. Seven years later, the *Castroville News* reported, "The future looks bright indeed for a permanent harbor at Moss Landing and shows conclusively what can be accomplished by hard work and the untiring zeal of one man . . . in the near future much freight will be included at Moss Landing and Mr. Sandholt will have proven to the doubting community that the harbor has come into its own." (Courtesy of the Pajaro Valley Historical Association.)

Prosperous San Francisco banker J. Henry Meyer saw some beautiful Ayershire cows at San Francisco's 1915 exposition. He thought these cows would be the perfect bucolic addition to the rolling hills of his Elkhorn Slough property. Before long, he had a full-fledged dairy operation. In its early years, the Elkhorn Dairy supplied all of Stanford University's milk. (Courtesy of the Elkhorn Slough National Estuarine Research Reserve Collection.)

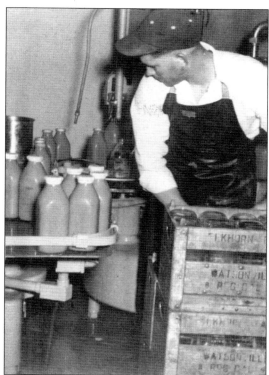

In 1916, David and Ed Vierra established a saltworks on the site of Paul Lazere's abandoned "City of St. Paul." The area was a natural basin where salt was produced for rough use but never refined. They built an extensive commercial plant spread over 5,000 acres. The product was used locally and shipped by rail and boat to San Luis Obispo and Santa Barbara. (Courtesy of the Monterey County Library.)

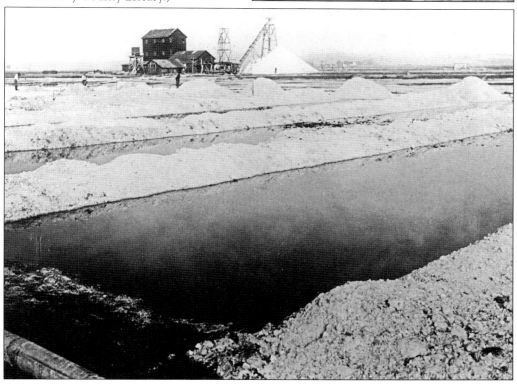

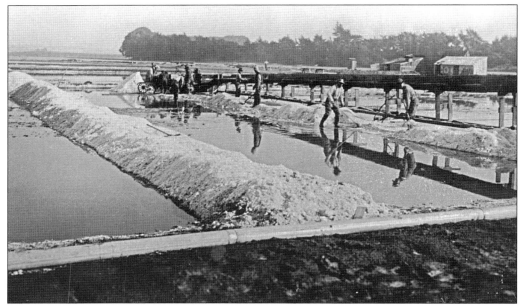

Workers tend the evaporation ponds at the Vierra family's Monterey Bay Salt Company. The process required five stages of evaporation. Raw seawater was pumped into a pond and then diverted into a series of beds as the product became more dense. In the final bed, the salt was rolled with fresh seawater and drained to eliminate magnesium. It was then harvested. A crew of 13 men could harvest 200 tons of salt per day. (Courtesy of the Monterey County Library.)

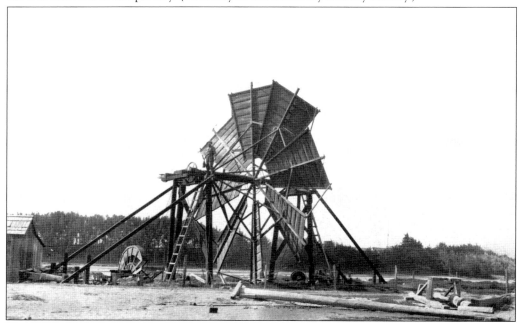

The Vierras—David, Ed, Joseph, and Albert—developed all the machinery for the saltworks, often using junk parts from automobiles. This huge windmill, one of their designs, operated from 1909 to 1935, pumping seawater from one evaporation pond to another. David Vierra was caught in some of the machinery and killed in 1924. (Courtesy of Pat Hathaway, California Views.)

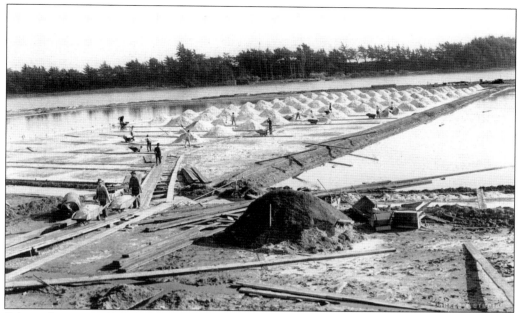

Salt production took one season, running from April to December. Harvesting started right after Labor Day. The salt was piled in huge, white mountains, with the annual output averaging 4,500 tons. Between 1913 and 1936, 80 percent of the salt was used in the local fish canneries, with shipments of up to 20 tons a day. It was also shipped by rail for use in water softeners and ice-cream plants. The Monterey Bay Salt Company remained a Vierra family enterprise until 1957. (Courtesy of the Monterey County Library California History Room Archives.)

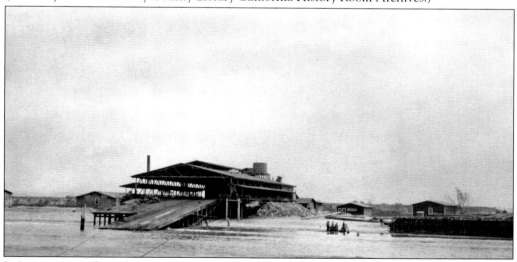

In January 1919, the California Sea Products Company opened a whaling station at Moss Landing. The company's two steam-driven chaser boats, *Hercules* and *Traveler*, searched for whales up to 100 miles offshore. In those days, humpbacks, finbacks, sulphur-bottoms, and even California gray whales could be found feasting on the sardine-chocked waters of Monterey Bay. On some days, the boats hauled three or four whales back to the station at one time. In the first year, the company took 234 whales, each valued at approximately $3,000. (Courtesy of the Monterey County Historical Society.)

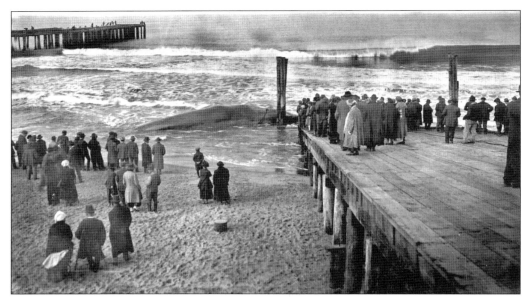

The first whale was pulled in on a foggy day in January 1919 before a crowd of curious onlookers. The newspaper reported, "A chain was fastened around the slippery tail and preparations made to haul the huge mammal into the station. All stood back from the proceedings (whales smell horrible!) with the exception of a few officials . . . by a queer fluke, the chain became disengaged, the whale flipped, and so did some of the spectators, right into the chilly Pacific." (Courtesy of Pat Hathaway, California Views.)

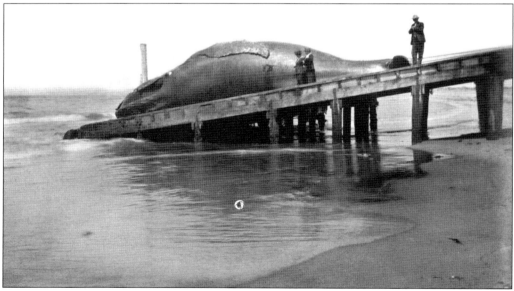

A whale waits to be pulled up the inclined spillway leading up from the beach. The thick cable attached to the whale's tail was slowly pulled up by a huge steam engine. Whales could weigh over 30 tons. When the whale was halfway up, flensors in cork bottom boots began cutting up the whale. Bill Lehman remembers the stench, "People always knew where you came from. You couldn't wash it off. The smell had to wear off. You could smell Moss Landing clear back to Prunedale when the wind was right." (Courtesy of Pat Hathaway, California Views.)

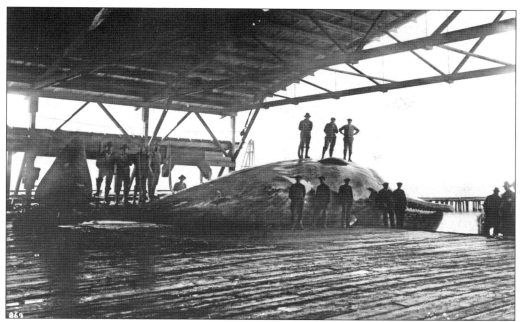

Flensors go to work on a whale at Moss Landing. Working in groups of two or three, it took 15 flensors 90 minutes to cut up a whale. Using 18-inch, razor-sharp blades with three-foot handles, the men worked systematically to peel blubber from the carcass. Cork bottom boots prevented the men from slipping off the upturned belly. (Courtesy of Pat Hathaway, California Views.)

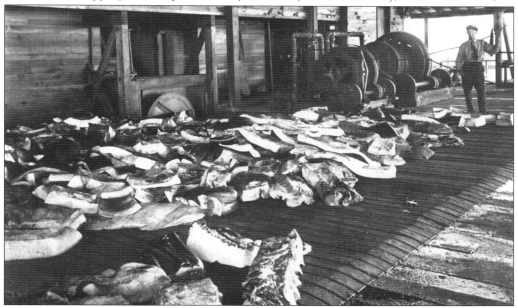

Eighteen large, wooden, cooking pots full of steaming water lined the inside of the Moss Landing whale try works. As flensors cut up the giant whale, the blubber, seen here, was boiled in the pots until the rich oil rose to the surface. The oil was sold in four grades. Eventually offshore factory ships, the declining whale population, and a drop in the price of whale oil caused the station to close in 1926. (Courtesy of Pat Hathaway, California Views.)

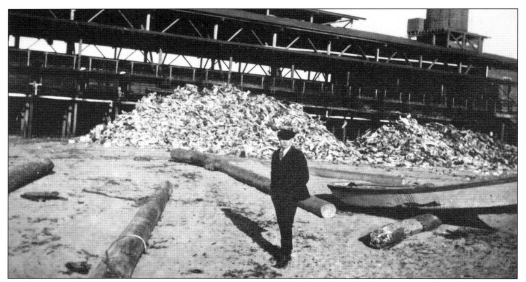

Mountains of whale bones wait to be dried, ground to a coarse powder, and then sold as bone meal. Every part of the whale was used. The average 40-foot whale produced 13,000 pounds of oil, 2,000 pounds of bone meal, 200 pounds of gill bone, and over 20,000 pounds of meat. Oil went into soap, cosmetics, paint, and glycerin for explosives. The tail tendons were made into glue, and the tail itself was sliced, salted, and sold in Japan as a delicacy. Meat was canned for dogs and cats and, during World War I, for human consumption as well. (Courtesy of the Monterey County Historical Society.)

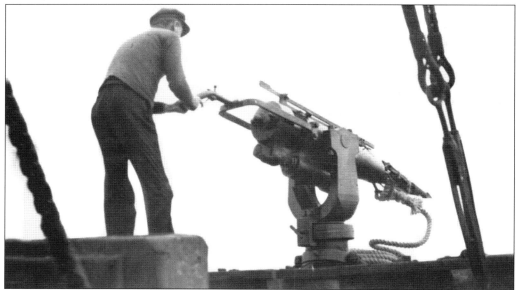

Pictured is the 100-pound harpoon and 90-mm cannon aboard the *Hercules*. On December 12, 1918, the *Salinas Weekly* reported, "The whale killing cannon for which the California Sea Products Company, owners of the whaling plant at Moss Landing, has long been expecting from Norway has at last arrived in San Francisco and during the next few days will be installed on the steamer Hercules." The head of each harpoon was packed with a heavy charge of black powder that exploded on impact with the whale. (Courtesy of Pat Hathaway, California Views.)

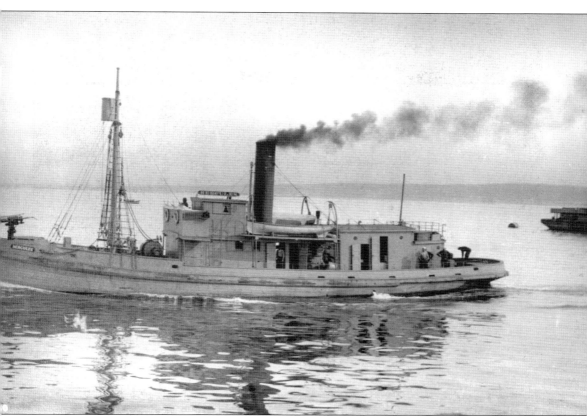

The whaler *Hercules* steams into Moss Landing. In 1919, the *Boston Evening Transcript* described this whale sighting: "Thar she blows—Oscar Hansen high aloft in the crow's nest of the whaler Hercules lifted his voice in mighty tones and pointed to where a 100 yards off the port bow a huge dim shape of gray blotched the blue sea amid a crinkling wash of sudden foam, out of the midst of which there jetted a thin white stream that was blown into shreds by the brisk northerly wind." (Courtesy of Pat Hathaway, California Views.)

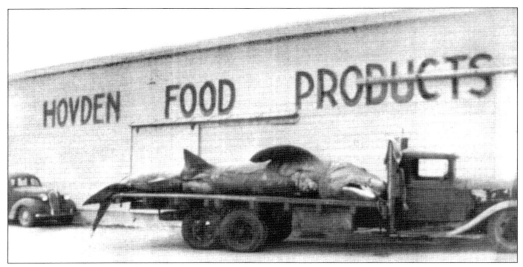

In the 1930s, Monterey Bay was often filled with gigantic basking sharks. Each shark could weigh between four and seven tons and could barely fit on a long bed truck, seen here. The shark's liver weighed up to 3,500 pounds and was harvested for its oil. Early on, the oil was marketed as a tonic for the digestive system. Later it was used for tanning leather. The shark's carcass was ground up for pet food at the nearby Hovden Cannery. (Courtesy of Pat Hathaway, California Views.)

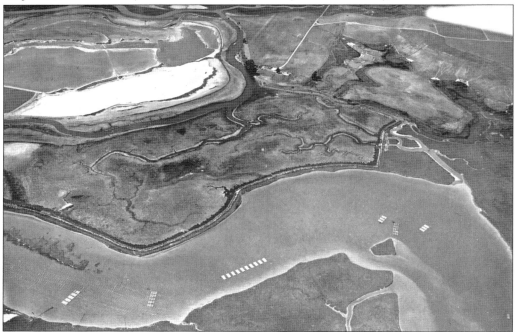

In 1904, the enterprising Vierra family planted oyster beds in Elkhorn Slough. Their project took 20 years to produce results, but on September 13, 1924, they announced "a new industry for Moss Landing, which is destined to be as profitable . . . as the whaling business and not nearly as offensive to the smell . . . henceforth, Monterey Bay oysters will be as well known, especially on the Pacific Coast, as blue points, and will be just as pleasing to the palate if not more so on account of their freshness." (Courtesy of Pat Hathaway, California Views.)

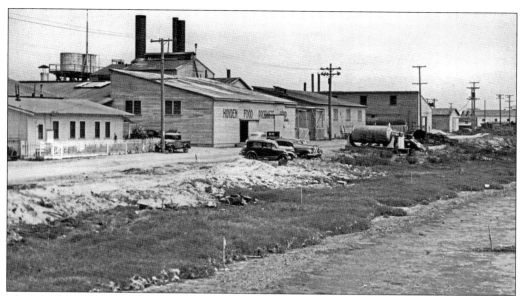

The Hovden Food Products Cannery in Moss Landing was built on the site of the former Pacific Coast Sea Products whaling facility in the 1930s. This cannery, along with nine others, was part of the booming Monterey Bay sardine fishery. An article in the *Register Pajaronian* reported, "Fish canneries in the Moss Landing area ended their third week of 1950 operations with approximately 450 persons employed, according to Lloyd Phillips, superintendent of the Moss Landing Hovden Plant." (Courtesy of the Pajaro Valley Historical Association.)

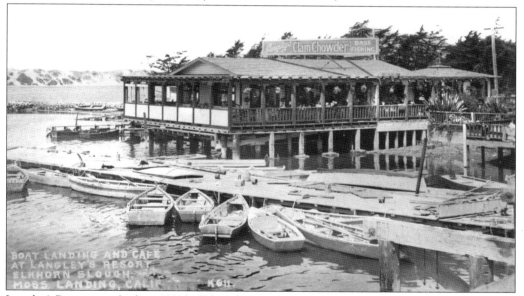

Langley's Restaurant, built in 1921 by Edward Vierra, was next to the Elkhorn Slough Bridge. Frank "Bud" Capurro remembers his parents taking him there in the 1930s. Besides seafood dinners, there was dancing on Friday and Saturday nights. It was later operated by the Mori Brothers until 1951, when Floyd and Laura Pereira bought the business and renamed it the Harbor Inn. The two subsequent owners, the Genoveses and Maloneyes, retained the name. (Courtesy of Pat Hathaway, California Views.)

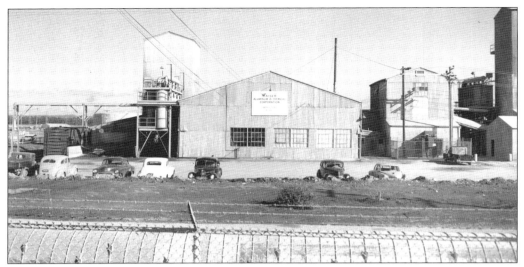

At the outset of World War II, Permanente Metals Corporation purchased property in Moss Landing to build a plant for the production of metabolic magnesium. Dolomite from a nearby mine in Natividad was mixed with seawater pumped from Elkhorn Slough. One ton of magnesia could be extracted from 144,000 gallons of water. The product was used in incendiary bombs. After the war, Kaiser Refractory built a facility next door, on the site of the "booze barn" used by rumrunners during Prohibition. Here heat resistant refractory bricks were manufactured for use in the steel, glass, and cement industries. (Courtesy of the Elkhorn Slough National Estuarine Research Reserve Collection.)

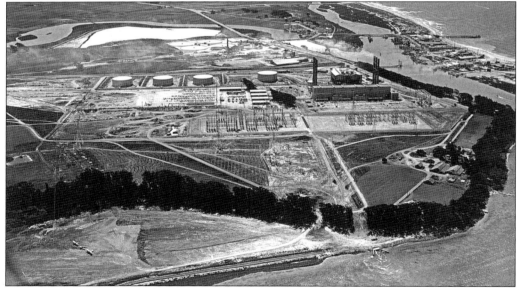

As part of their postwar expansion program, the Pacific Gas and Electric Company built an electric plant at Moss Landing in 1949. At the time, it was the world's second largest fossil fueled generating electric plant, generating 2,060 megawatts of power for the west coast. In 1950, a newspaper reported, "In a major construction achievement [the plant] was placed in service just 18 months and 23 days after ground was broken in a broccoli field in September 1948." (Courtesy of the Monterey County Agricultural and Rural Life Museum.)

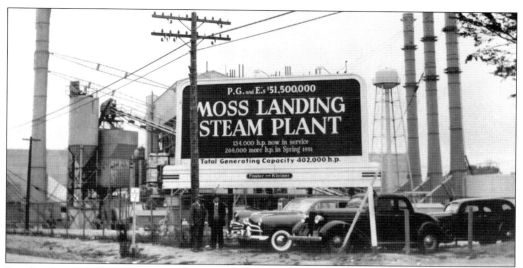

Pacific Gas and Electric Company's $51.5 million "Mighty Moss" was put into service in 1950. The newspaper reported, "Everything is on a big scale in this plant. The turbine room is 461 feet long; there are six boilers, each as tall as an eight-story building. The six boiler stacks are landmarks towering 225 feet high. More than 20,000 tons of steel and 50,000 cubic yards of concrete went into construction of the great plant." (Courtesy of the Elkhorn Slough National Estuarine Research Reserve Collection.)

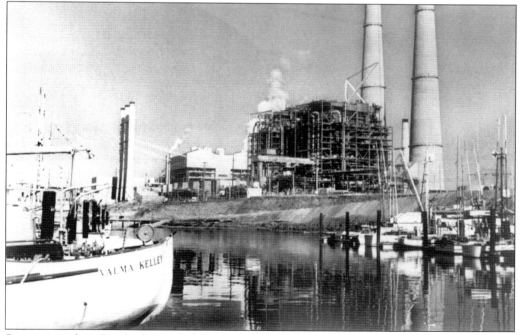

Steam rising from Pacific Gas and Electric's stacks is a familiar site along Monterey Bay's coastline. When constructed, the newspaper reported, "At full operation the six boilers will convert 1,650 tons of distilled water into steam every hour, superheating it to 950 degrees Fahrenheit. After the steam has given up its energy in spinning the turbine-generator it is condensed." (Courtesy of the Monterey County Historical Society.)

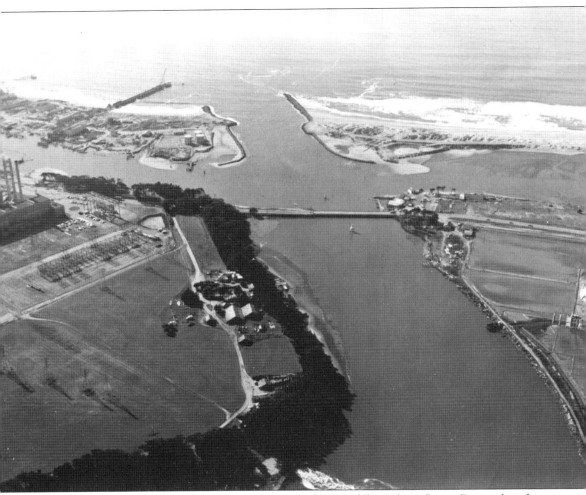

Some say that the 1906 earthquake changed the course of the Salinas River. Research indicates that the present river mouth was a secondary outlet, opened to prevent flooding. The original mouth was eventually blocked by silt from surrounding farming operations. In 1946, the Army Corps of Engineers constructed the present channel into Monterey Bay. (Courtesy of the Monterey Public Library, California History Room Archives.)

Three

PAJARO

In 1824, Don Ignacio Vallejo was granted Rancho Bolsa de San Cayetano. There he built an adobe known as Casa Materna, or "mother house," since this was the first property owned by the Vallejo family in California. Many glass windows enclosed the second story, giving the adobe "the Glass House" moniker. Don Ignacio and his wife, Maria Antonio, had 15 children—eight daughters and five sons, one of whom was Gen. Mariano Guadalupe Vallejo. The adobe ruins were razed by a bulldozer in 1926. (Courtesy of the Monterey Public Library, California History Room Archives.)

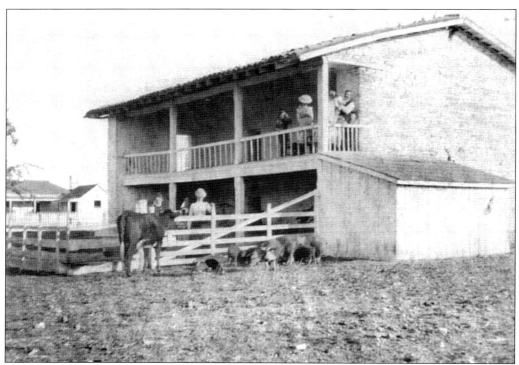

The Hipilito Adobe, once located on San Juan Road, was one of three adobes built by the Vallejos on Rancho Bolsa de San Cayetano. Built by Jesus, younger brother to Mariano, the adobe had 18-foot-high ceilings and 20-inch-thick walls on the second floor. The adobe was severally damaged in the 1906 earthquake. Owner J. C. Beilby planned to demolish the building when Dr. Saxton Pope brought the property and hauled the adobe bricks and tiles to Watsonville to build a new house. Pictured are members of the Beilby family. (Courtesy of the Pajaro Valley Historical Association.)

When William Henry Rowe was 14 years old, he left his home in England to become a sailor. He sailed into the port of San Francisco shortly after gold was discovered, promptly deserted ship, and struck out for the mines. His success in the gold fields was unremarkable, but he liked California and decided to stay. In 1853, he purchased land in the Pajaro Valley and started farming. (Courtesy of the Pajaro Valley Historical Association.)

In 1854, the Trafton family, headed by Sarah Trafton, who lost her husband David on the journey west, settled on a tract of land in northern Monterey County on the Pajaro River. With her were her five children, including George Arthur pictured here. George later married Melissa Marthis in Sacramento, and the family became prominent members of the community. (Courtesy of the Pajaro Valley Historical Association.)

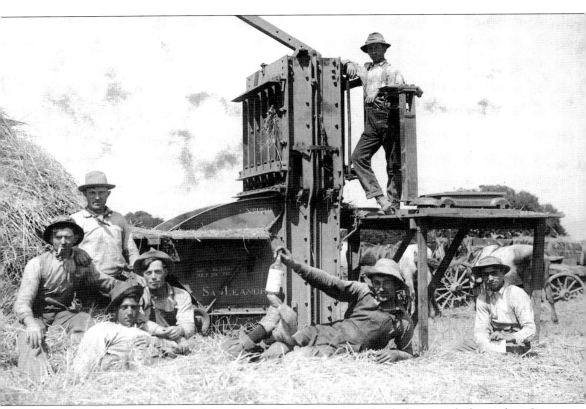

Workers take a much-needed break while baling hay on the Nicholson ranch, located on San Juan Road. Murdock Nicholson settled in the area in 1867. His pregnant wife, Sarah, was shot by Matt Tarpy in 1873 over a property dispute. Tarpy was later lynched for the murder. Hay press crews worked from dawn to dusk during the hottest, driest time of the year. They ate five meals a day to keep their energy up for the heavy job of tying, rolling, and stacking the 325-pound bales. (Courtesy of the Pajaro Valley Historical Association.)

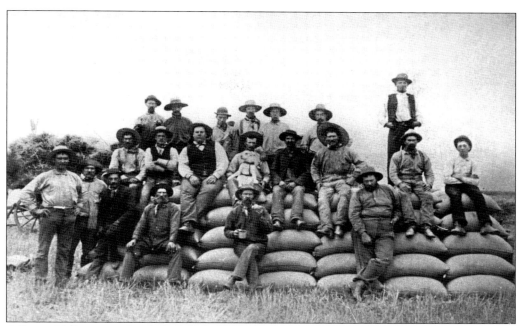

A Pajaro Valley grain threshing crew rests on the fruit of their labors. Seated in the center is Jim Rowe, with a cup in his hand. During the last quarter of the 19th century, grain farming thrived in the Pajaro Valley. In 1875, the *Pajaronian* reported that at the Pajaro Depot, "tier upon tier of valuable grain piled nearly to the roof twenty feet high, greets the visitor, and shows as well the great productiveness of the valley." (Courtesy of the Pajaro Valley Historical Association.)

A steam-powered threshing machine is hooked up to a water wagon by rubber hoses. Threshing engines required up to 700 gallons of water a day. The crew's engineer used only the best water for his engine, insisting, "If you won't drink it, don't put it in your boiler." (Courtesy of the Monterey County Library, Aromas Branch.)

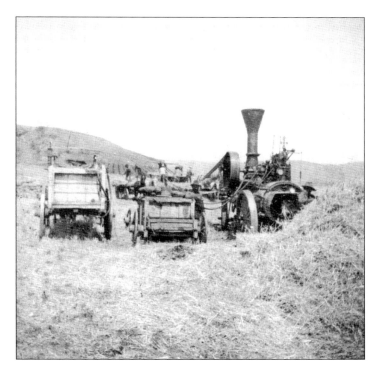

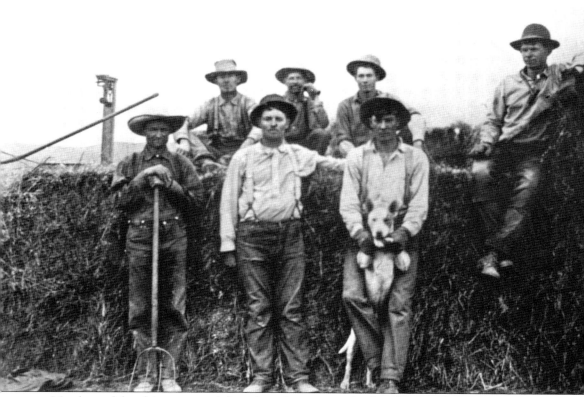

Members of threshing crew and their dog take time out for this photograph to be taken. During the 1870s, a typical crew consisted of 18 men, an engineer, 2 feeders, a sack sewer, and 14 laborers. When the low Derrick Table was introduced, a flatbed wagon that conveyed the grain from the stack to the thresher, crews were reduced by a third. (Courtesy of the Monterey County Library, Aromas Branch.)

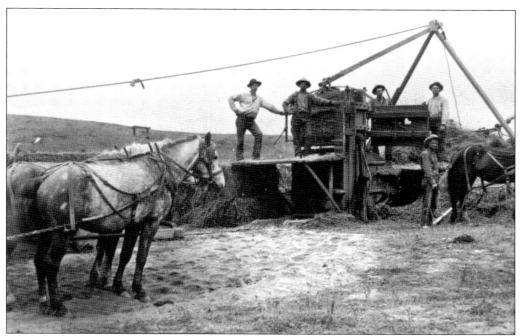

Pictured is a baling crew hard at work. The horses in the foreground powered the press. They were driven in a circle to operate a winch. Boys usually had the job of overseeing the horses. This was the least arduous but most monotonous job on the crew. (Courtesy of the Monterey County Library, Aromas Branch.)

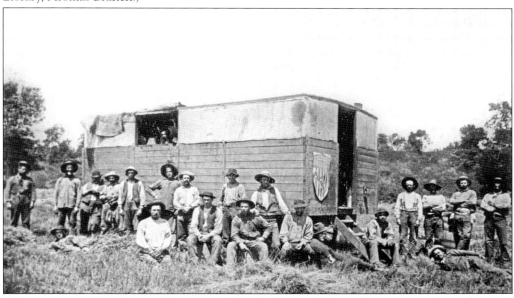

A harvesting crew on the Mark Regan ranch in the Pajaro Valley gathers around the cook wagon for a well-deserved break. As described by the *Monterey Democrat* in 1888, the cook wagon was "a kitchen on wheels, and as neat as any housewife's ordinary kitchen, and is probably twice as convenient, for the size is ample, having a long center table, capable of accommodating twenty men." (Courtesy of the Pajaro Valley Historical Association.)

In 1850, 20-year-old John T. Porter arrived in San Francisco and made his way to the gold fields near the Yuba River. After little success, he joined his two cousins in the Soquel area. Porter lost little time in making his mark, being elected sheriff of Santa Cruz County in 1857. Four years later, President Lincoln appointed Porter to be collector of the Port of Monterey. In 1874, Porter purchased 820 acres of the San Cayetano Rancho from the Vallejo family. (Courtesy of the Pajaro Valley Historical Association.)

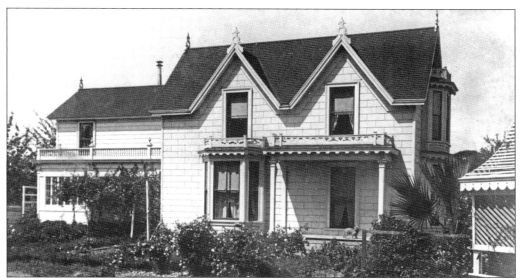

Included in the property Porter purchased from the Vallejo family was a six-room house that Juan Antonio Vallejo had built for his bride-to-be. Before the wedding could take place, Juan Antonio fell from his horse and broke his neck while attempting to lasso a bull. The Porters moved the house from its riverbank location in 1871. In 1874, they extensively remodeled the house in the Gothic Revival style seen here. The only portion of the Vallejo house that was retained was the left rear near the back entrance and the kitchen. (Courtesy of the Pajaro Valley Historical Association.)

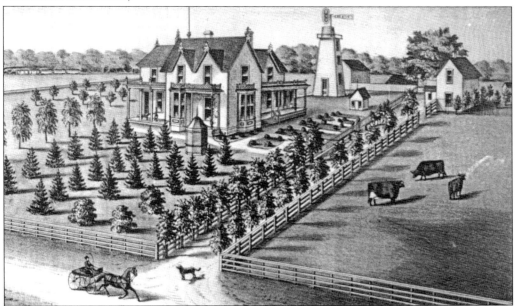

The tasteful grounds of the Porter house are captured in this 1880s lithograph. The Gothic Revival remodel coincided with John T. Porter's establishment, along with six partners, of the Bank of Watsonville. His home's landmark presence was appropriate for a man who was assuming a key role in the economic life of the Pajaro Valley. (Courtesy of the Pajaro Valley Historical Association.)

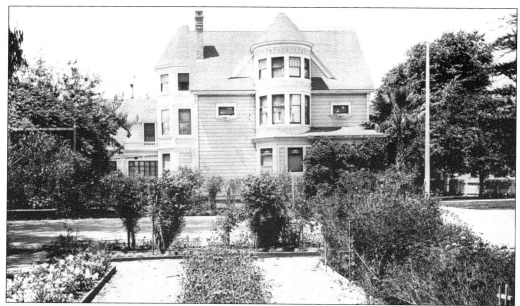

Between 1895 and 1899, noted California architect William Weeks remodeled the Porter home into a 23-room, three-story Queen Anne mansion. Weeks took great care and used quality materials to transform the Porter's home into "one of the handsomest homes in this section of the state." Besides being the first home with electric lights, the house featured a large dining room, china room, billiards room, and library. (Courtesy of the Pajaro Valley Historical Association.)

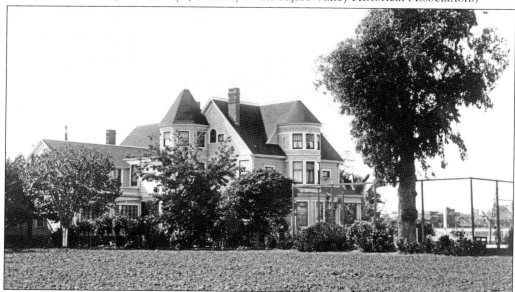

In 1905, Florence Porter Pfingst hosted a party in her home. Refreshments were served in a corner of the tennis court, visible at right. There was also a rustic dancing pavilion set up on the grounds. The newspaper reported, "The beauty of the Porter home with its luxuriant gardens and shaded walks, the comfortable coolness of the day, the entrancing music, and withal the happy feeling of welcome, made the affair a complete success." (Courtesy of the Pajaro Valley Historical Association.)

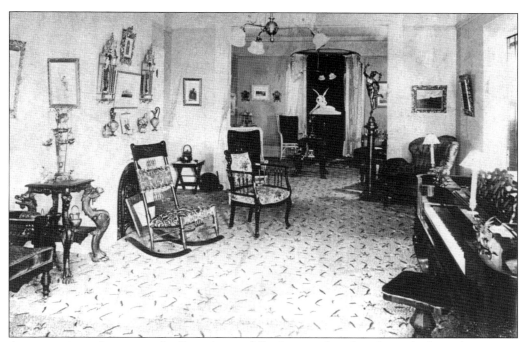

A square piano dominates the Porter's tastefully decorated parlor. Ornately framed paintings adorn the walls and statuettes of Cupid, Psyche, and Mercury further attest to the family's esthetic inclinations. (Courtesy of the Pajaro Valley Historical Association.)

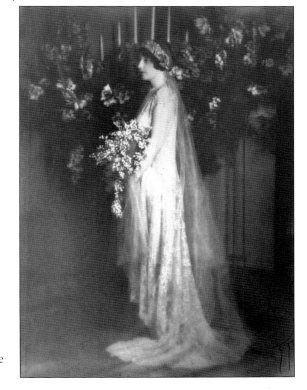

Bernice Huggins Porter is pictured on her wedding day. Her husband, Thomas B. Porter, brought her to the Porter ranch on Hall Road in 1927. John T. Porter raised horses on this ranch; they were his "pride and joy." The Porter family donated a portion of the ranch adjacent to Elkhorn Slough to the Nature Conservancy for the protection of the wetlands habitat. (Courtesy of the Pajaro Valley Historical Association.)

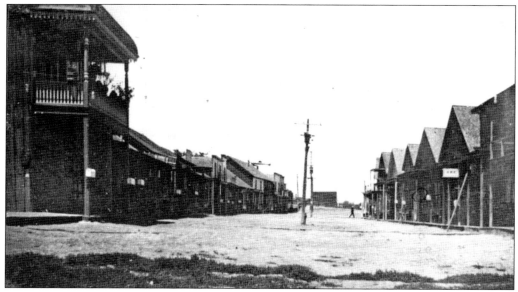

Anti-Chinese sentiments led to the removal of Watsonville's Chinatown across the river to John T. Porter's property in Pajaro. In the summer of 1888, Chinatown buildings were raised on skids and hauled over the county line. The community became known as Brooklyn, mirroring the relationship between New York's rough-edged Brooklyn and classy Manhattan. Eventually Brooklyn grew into one of California's largest Chinatowns. Pictured is Brooklyn at the beginning of the 19th century. Chee Kong Tong temple is seen on the far left. (Courtesy of the Pajaro Valley Historical Association.)

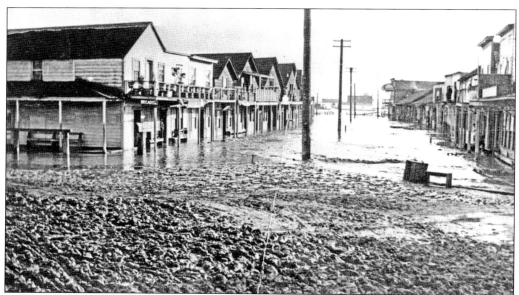

A flooded Brooklyn is pictured in 1911 when over 28 inches of rain caused the Pajaro River to overflow its banks. The community's proximity to the river led to many floods over the years. Stoic residents simply moved their belonging upstairs and waited for the water to recede. (Courtesy of the Pajaro Valley Historical Association.)

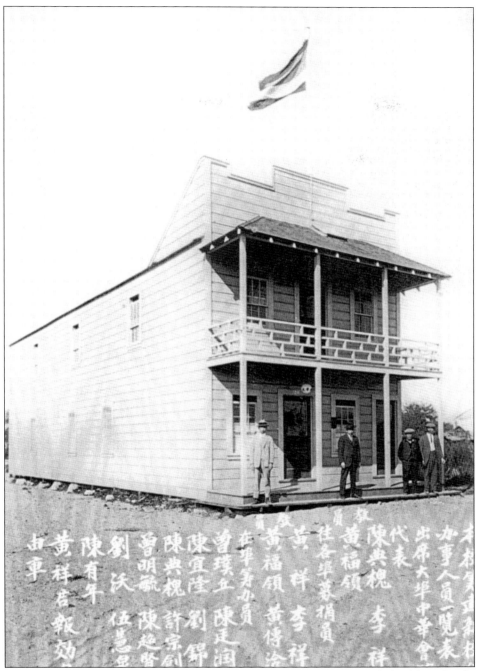

Brooklyn's Chinese families established a school in 1916. Children attended public school until mid afternoon and then Chinese school from 4:30 p.m. to 8:30 p.m. Albert Wong remembers that tuition was $3 a month. Students were taught the Chinese language, culture, and history. In 1924, the first school, located at 35 Brooklyn Street, burned down. A new school, pictured here, was built across the road at 18 Brooklyn Street. The school was in continual use until World War II. (Courtesy of the Pajaro Valley Historical Association.)

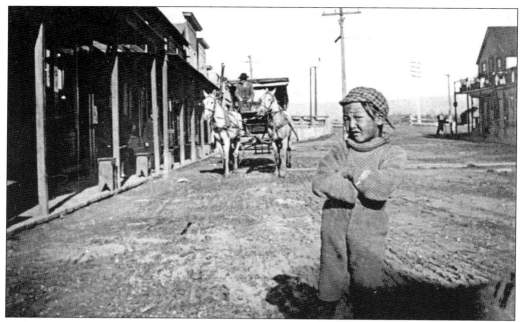

A dubious child is captured by the camera as the photographer snaps a picture looking from Brooklyn Street to the Pajaro River Bridge. Chinatown residents were served by several businesses that lined Brooklyn Street, including grocery and general merchandise stores, two drug stores or herbalists, and one restaurant. (Courtesy of the Pajaro Valley Historical Association.)

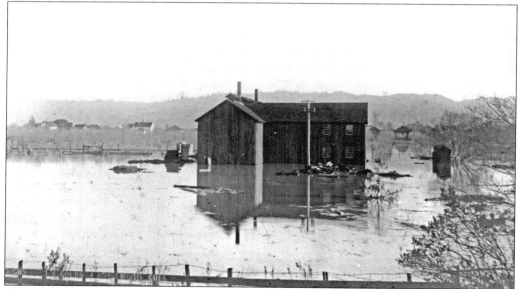

The Pajaro Valley's apple crop was sold fresh, dried, and as cider. Several Chinese families operated apple dryers. Pictured is the Pacific Operating Company, located near the Main Street Bridge on San Juan Road. The company was first run by Fan Yuen, M. C. Sang, and Ng Ying. Later Eng Chung (Sam Eng) operated the business, then known as the Central Evaporating Company. Workers were given room and board and made between $2.50 and $3 a day, laboring from 7:00 a.m. to 6:00 p.m. (Courtesy of the Pajaro Valley Historical Association.)

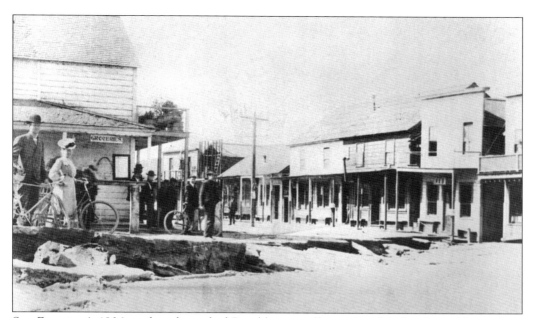

San Francisco's 1906 earthquake rocked Brooklyn as well, creating this four-foot-wide, six-foot-deep rupture across the corner of Brooklyn and San Juan Streets. At the far left are bicycle riders Mr. and Mrs. S. A. Steitz. Mr. Steitz was a bicycle dealer in Watsonville. The first building on the right was Charley Fang's store and saloon. Next door was his gambling house, with prostitutes available in the back rooms. (Courtesy of the Pajaro Valley Historical Society Association.)

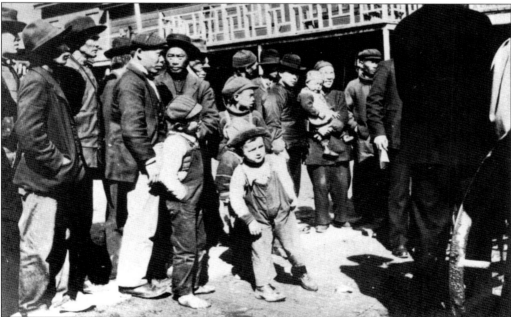

Residents of Brooklyn and Watsonville gather to view damage created by the 1906 earthquake. At the Pajaro Depot, the water tank collapsed into the engine house, demolishing most of that structure. Damage to the railroad tracks stopped all train traffic until April 20. (Courtesy of the Pajaro Valley Historical Association.)

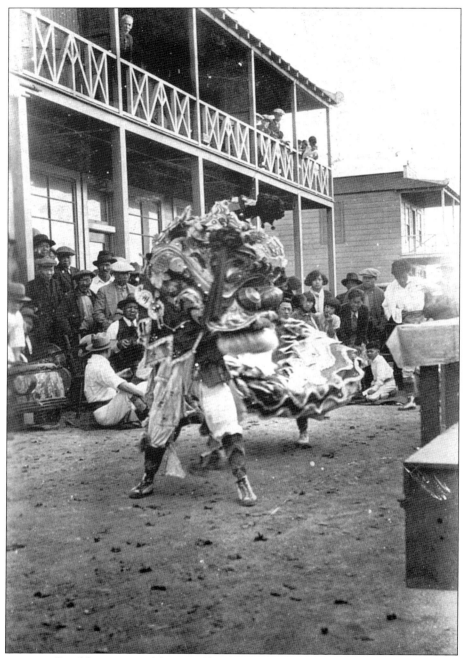

Growing up in Brooklyn meant celebrating Chinese New Year. Here the Lion Dance is performed on Brooklyn Street in 1927. The lion was believed to chase away evil spirits and bring luck. Merchants hung lettuce or cabbages outside their shops to attract the lion dancers. It was very fortuitous if a merchant's head ended up in the lion's mouth. Drummers followed the lion down the street, their continual beat representing the sound of the lion's heart. Collin Dong remembers that the community "came to contribute money for the poor by giving to the collectors during the lion and dragon ceremonial dances." (Courtesy of Pajaro Valley Historical Society Association.)

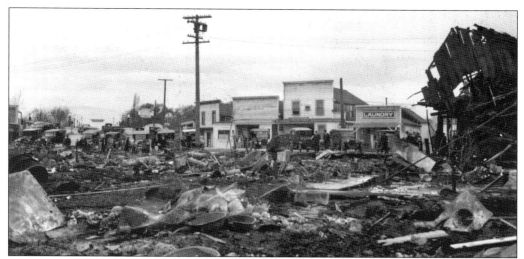

Chinatown suffered a disastrous fire in 1924 and again in 1933. After the last fire, the Porter family subdivided the land and sold the property, except for the Chinese school lot, which was purchased by the Chinese Association. Here just a few buildings remain standing after the second fire. (Courtesy of the Pajaro Valley Historical Association.)

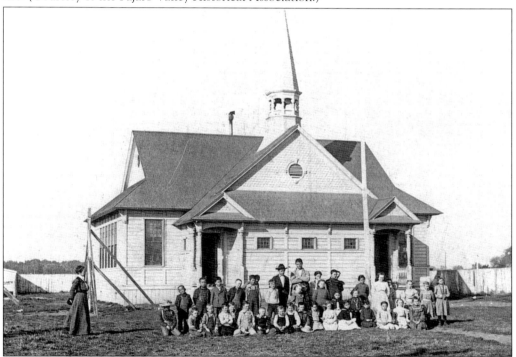

On April 25, 1862, the *Pajaro Times* reported that a new school district, called the Lindley District, was established. The two-room schoolhouse built during the Civil War was replaced in 1887 with a Queen Anne building designed by Alex Chalmers. Although the school was considered a model educational facility, its location near the depot had drawbacks. One description relates that "Cattle were often held just outside the school grounds as they waited to be shipped by rail. The noise of the beasts could be deafening." (Courtesy of the Pajaro Valley Historical Association.)

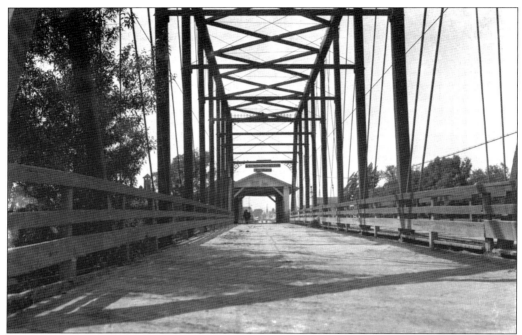

Buggies are warned to cross the Pajaro River Bridge no faster than a walk or face a $5 fine. In the 1860s, "Dutch John" operated a ferry between Watsonville and Pajaro. In 1868, he built a covered bridge on the Watsonville side, which met up with a steel, open bridge on the Monterey County side. In 1915, both spans were torn down and replaced with a concrete bridge. (Courtesy of Pat Hathaway, California Views.)

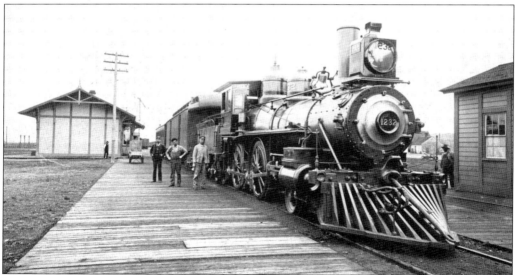

In 1871, the Southern Pacific Railroad laid tracks through Chittedon Pass, linking Pajaro with Gilroy. The first train from San Francisco steamed into the new junction on November 25. Jubilant residents of Watsonville and Pajaro boarded a special excursion train bound for Sargent's Station where they celebrated with a picnic in a nearby grove. (Courtesy of the Pajaro Valley Historical Association.)

In 1920, a promotional brochure described Pajaro's depot as a principal industrial center. "It is a railroad division point, with a big roundhouse (pictured here) and extensive railroad yards. All the trains of the coast division stop there, and great numbers of freight trains are made up at that point. A large number of men are employed at this point to handle the great volume of business . . . it is one of the busiest little places in the West." (Courtesy of the Pajaro Valley Historical Association.)

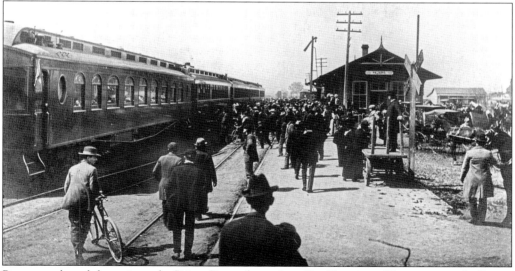

Passengers board the train at the Pajaro Depot for a trip to San Francisco. The train was the Pajaro Valley's economic lifeline to distant markets. In 1875, the Watsonville *Pajaronian* reported, "The farmers in this section have much for which to thank the railroad . . . freights are low, employees are prompt and faithful, and the greatest care is exacted from them for all merchandise placed in their charge. In point of business, the Pajaro Depot is second in importance on the Southern Pacific." (Courtesy of the Pajaro Valley Historical Association.)

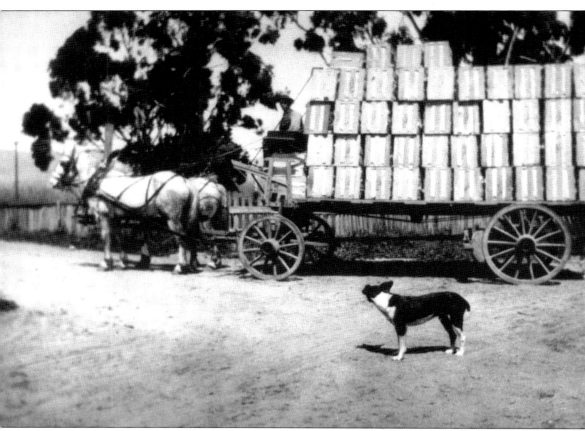

In the fall of 1915, Mose S. Hutchings planted three acres of lettuce on the Rowe Ranch. The lettuce was harvested at 2:00 a.m. by lantern light, field packed, and loaded in a wagon. Pictured is Hutchings driving that first load of lettuce to the Pajaro Depot in a wagon pulled by horses Lizzie and Blue while Scoop the dog looks on. At the depot, he shipped the crates to Henry P. Garin in San Francisco, who sold them for $2.50 each. (Courtesy of the Pajaro Valley Historical Association.)

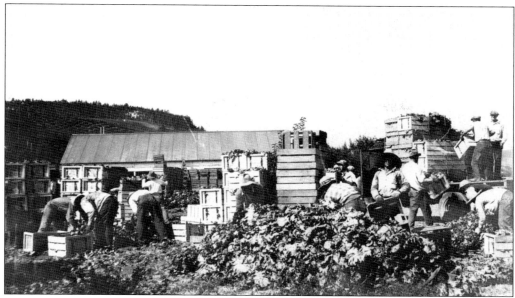

Pictured are Orrin O. Eaton's lettuce crew field packing lettuce near Hunter's Hill in the 1920s. In 1952, one observer noted, "Orrin O. Eaton is credited with bringing the magic touch of lettuce to Monterey County. In 1917, inspired by Hutching's example, he planted a few patches between the berries on his Oak Grove ranch. By 1922, he had started his own shed (on San Juan Road), using methods which will still form the basis of present packing house procedures." (Courtesy of the Pajaro Valley Historical Association.)

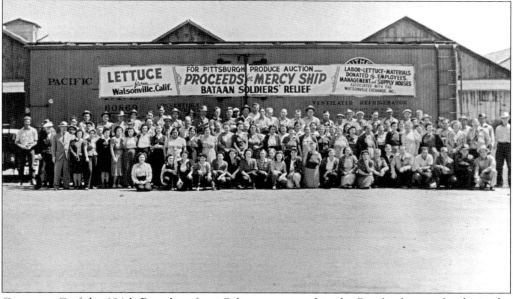

Company C of the 194th Battalion from Salinas, stationed in the Pacific theater, fought in the bloody battles of Corregidor and Bataan. Only 46 of the 200 men from Salinas survived the infamous Bataan Death March. Folks back home rallied to raise $25,000 to augment Red Cross supplies for captured American forces. Pajaro Valley lettuce, sent east by rail, was auctioned off—raising $4,200 for the relief effort. (Courtesy of the Pajaro Valley Historical Association.)

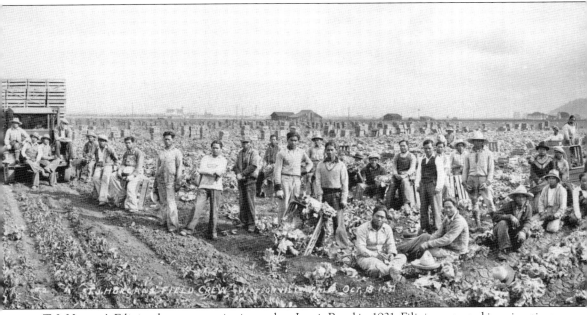

T. J. Horgan's Filipino lettuce crew is pictured on Lewis Road in 1931. Filipinos started immigrating to the United States in the 1920s, finding work on Salinas and Pajaro Valley farms. Laborers were paid 25¢ an hour—wages they felt were discriminatory. In response, Luis Aguido and Damian

Workers tend to the strawberry crop at the Clough Ranch on San Juan Road. Notice the redwood flume in the background that carried irrigation water to the fields. A promotional brochure published in the 1920s boasted, "Fruit and berry growing are now the principal factors in the growth of the Pajaro District. As a berry section it ranks among the greatest in the state. Strawberries in particular are raised here in great quantity and of the best quality." (Courtesy of the Pajaro Valley Historical Association.)

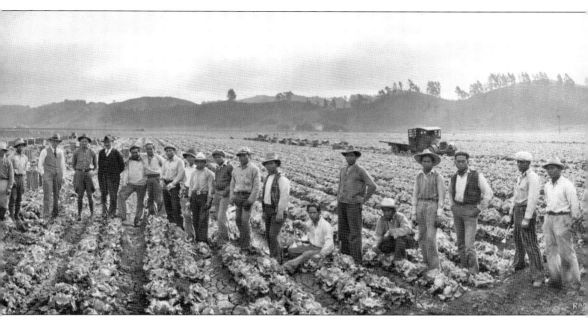

Marcuelo founded the Filipino Farm Labor Union in 1934, which gave Filipino workers some bargaining power. (Courtesy of the Pajaro Valley Historical Association.)

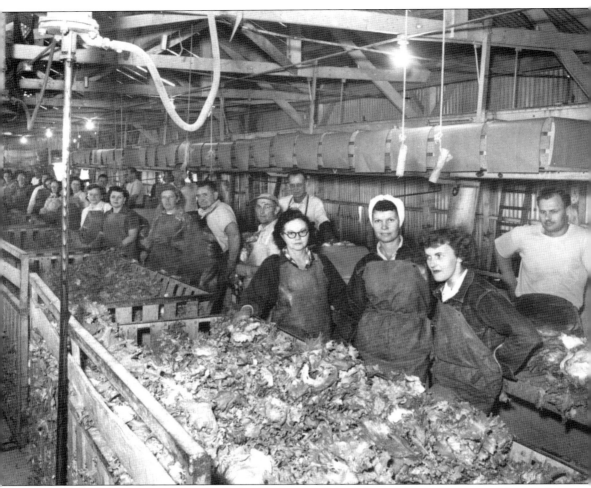

Lettuce trimmers are pictured at Birbeck's shed on Salinas Street. Several other packing sheds were clustered around the Pajaro Depot. After trimming, lettuce was placed in a wooden crate lined with wax paper. Lettuce was packed in layers, usually 12 heads to a layer. Ice was shoveled in, and the process continued until four to five dozen heads were packed. A lid was then nailed in place, and the crates were rolled to the waiting railcar. Eleanor Pavey, wearing the cap, was Birbeck's union shop steward. (Courtesy of the Pajaro Valley Historical Association.)

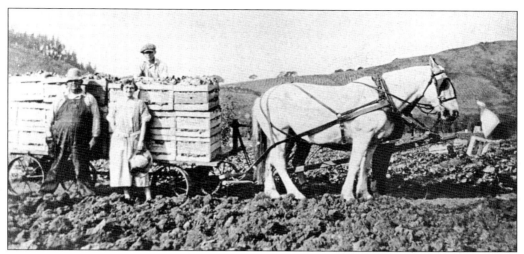

The Thwaits family poses with a wagonload of lettuce on their Pajaro Valley farm. Raising lettuce was dependent on horsepower early on. Listing was done with a two-horse team pulling a two-row cultivator. Planting was done with a one-row Planet Jr. pulled by a single horse. Harvesting started at 4:00 a.m. Lettuce was packed in field crates and hauled to the packing shed by horse-drawn wagon. (Courtesy of the Monterey County Agricultural and Rural Life Museum.)

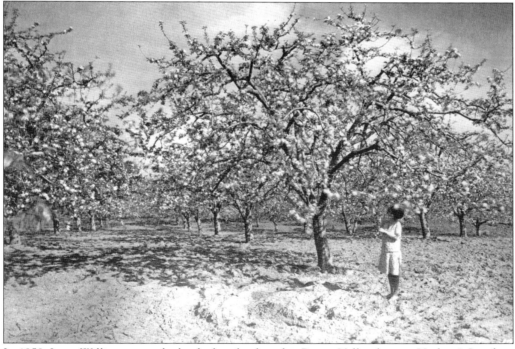

In 1858, Isaac Williams carted a load of apples from his Pajaro Valley farm to Hudson's Landing for shipment to San Francisco. The apples were grown on 20 acres that later became known as the Redman Ranch. From then on, apple acreage climbed steadily, and apples were shipped regularly from Port Watsonville and Moss Landing. One observer noted, "Our beautiful valley in blossom time seems a paradise of blossoms gently swaying in mild Pacific breezes." (Courtesy of the Pajaro Valley Historical Association.)

By the 1880s, Newton and Bellflower apples dominated the Pajaro Valley orchards. The area was perfect for their culture plus they were in high demand and got high prices. Apple acreage skyrocketed at the turn of the 19th century, reaching the million-tree mark spread over 14,000 acres. Eventually growers could expect each tree to yield 15 to 30 boxes of fruit and up to 1,000 boxes per acre. (Courtesy of the Pajaro Valley Historical Association.)

Four

AROMAS

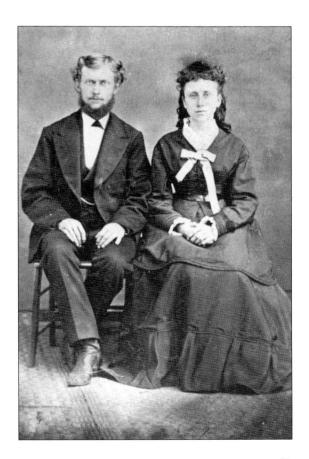

John and Harriet Slayton were married
in Salinas in 1874. They were one of
the first settlers in the Aromas area.
(Courtesy of the Monterey County
Library, Aromas Branch.)

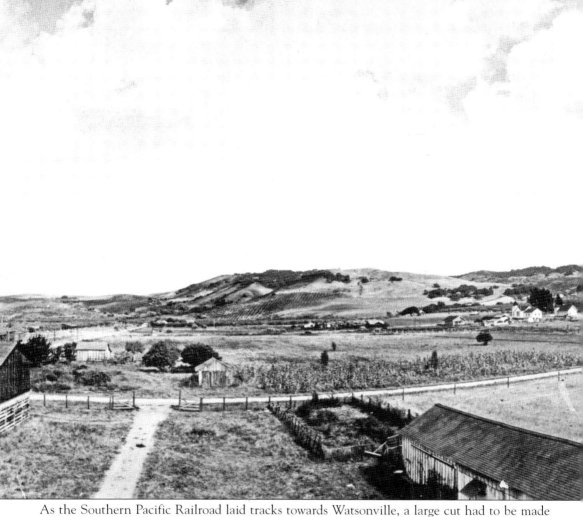

As the Southern Pacific Railroad laid tracks towards Watsonville, a large cut had to be made through the hills separating the Aromas and Pajaro Valleys. The area became known as Sand Cut. Recognizing that the area was well suited for settlement, a Mr. Bardue bought a portion of the Las Aromitas y Agua Caliente rancho. His ranch was later purchased by developers from

Gilroy, who surveyed a town site and residential lots. The name Aromas, derived from the original rancho, became official in 1894. By 1920, one observer noted that Aromas was "a fine little typical American town with a very fine class of people." (Courtesy of the Monterey County Library, Aromas Branch.)

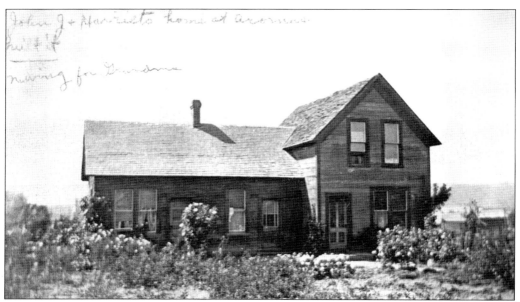

The Slaytons built a two-story home at 311 Carpenteria Road around 1895. Five years later, they added the one-story wing. In the 1930s, a Mrs. Haymer operated a nursing home at the house. (Courtesy of the Monterey County Library, Aromas Branch.)

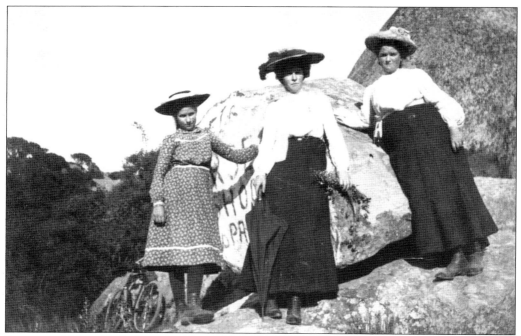

Emma and Mary Nicholson (in black skirts) pose with a friend at the San Juan Rocks. The Nicholson family grew apricots on their 1750-acre ranch that was located near the intersection of the Tarpy and San-Juan-Watsonville Roads. Neither Mary nor Emma married. (Courtesy of the Monterey County Library, Aromas Branch.)

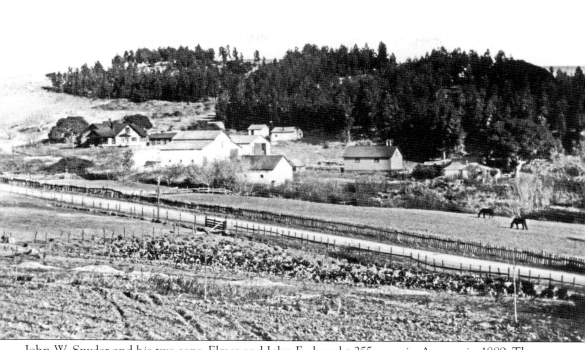

John W. Snyder and his two sons, Elmer and John E., bought 255 acres in Aromas in 1889. The Snyders were an early pioneer family, having originally settled near Watsonville in the 1860s. Their hired Chinese laborers to clear the oak trees from the ranch and then planted apricot trees. (Courtesy of the Monterey County Library, Aromas Branch.)

Three generations of the Hawkins family pose in front of their home at 401 Carpenteria Street around 1900. Grandmother Sarah McFall is flanked by her daughter Margaret and son-in-law Rufus Hawkins, who was born in Pennsylvania in 1857. (Courtesy of the Monterey County Library, Aromas Branch.)

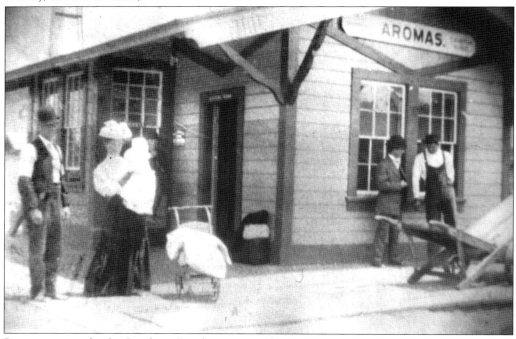

Passengers wait for the Southern Pacific to stop at the Aromas Depot in 1907. Station agent Floyd Hawkins, far left, stands next to his wife, Alice, who is holding baby Nevelle. (Courtesy of the Monterey County Library, Aromas Branch.)

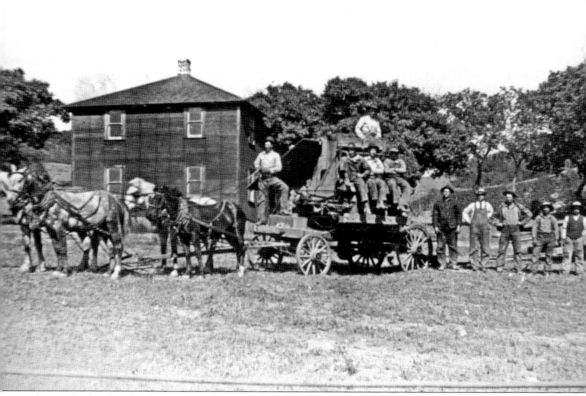

In 1909, the Chadwell family and other local farmers gathered at the Fowler home, which was located at the end of Snyder Avenue. Ed Chadwell drives the team, Dayton Chadwell is seated in the center on the wagon, Buck Chadwell stands next to the wagon, and Cliff Chadwell holds the horse on the far right. Mr. Fowler stands next to Cliff. (Courtesy of the Monterey County Library, Aromas Branch.)

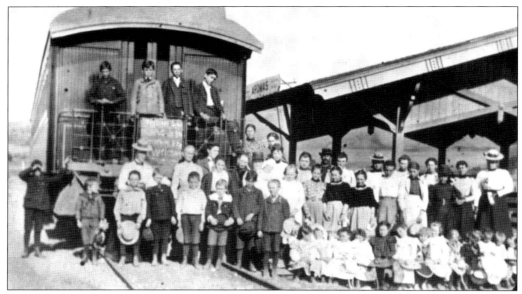

In 1893, Clara Baldwin and Elsie Torrey organized a Sunday school that met under an oak tree on Carpenteria Road. Later services were held in the schoolhouse, led by the Reverend E. B. Hatch from Gonzales. In 1899, he was able to have the Baptist board send their chapel car to Aromas, with Rev. J. B. Jacques and his wife as leaders. It remained at the siding for five weeks. Soon after, a Baptist church was organized with about 30 charter members. (Courtesy of the Monterey County Library, Aromas Branch.)

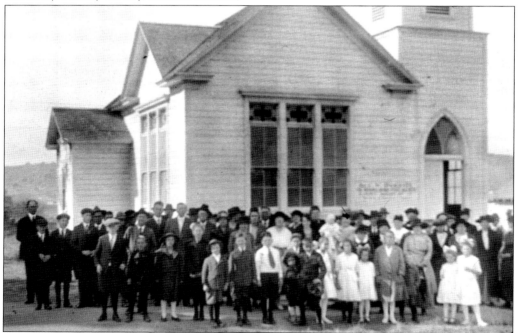

In 1901, the men and boys in Aromas built a one-room Baptist church, funded by public donations. Rev. A. J. Cable served as the first pastor. Pictured is the church in 1910, as the congregation celebrates a new addition. (Courtesy of the Monterey County Library, Aromas Branch.)

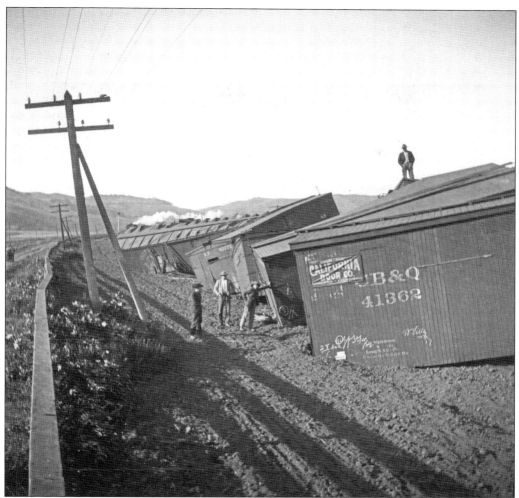

The 1906 earthquake shook Aromas residents awake on the morning of April 18. Station agent Floyd Hawkins found the SP station collapsed next to twisted tracks. Down the line, conductor Bouchard reported, "We had three cars of beans on the line . . . they turned over and burst open like ripe pods, spreading beans all over the countryside." (Courtesy of the Monterey County Library, Aromas Branch.)

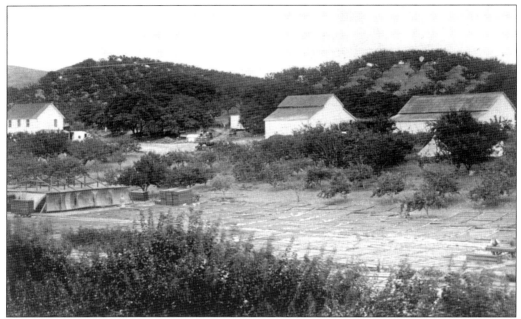

George Washington Seely purchased 250 acres adjacent to the Snyder family from Gilroy land developers. Like others in the area, he planted apricot orchards. The road that runs between the farmhouse and the barns is today's Pioneer Place. (Courtesy of the Monterey County Library, Aromas Branch.)

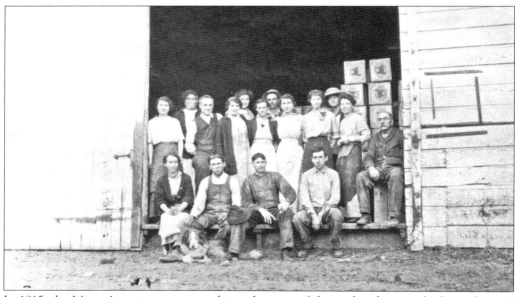

In 1915, the Meyers's apricot crew posed in a doorway of the packinghouse, which was located across the Southern Pacific tracks near the Aromas Depot. Pictured here, from left to right, are (first row) Mabel Dewey, Sanford Fly, Henry Laughery, and Bill Eipper. In the second row, surrounded by ladies, are Ed Jennings (far left), Jim Turney (center), and Mr. Tomolson (seated on a box). (Courtesy of the Monterey County Library, Aromas Branch.)

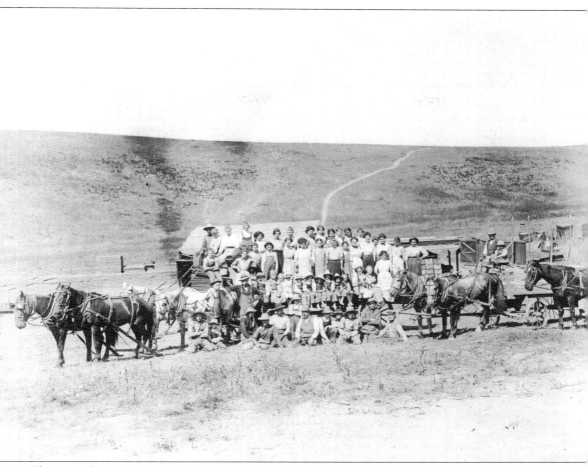

Elmer Snyder's apricot crew gathered for a photograph in his dry yard in 1925. Families from the San Joaquin Valley came to Aromas to work in the apricot orchards during the summer months. Farmers furnished campgrounds, free wood, and water. The trail in the background led over the hill to Carpenteria Road. (Courtesy of the Monterey County Library, Aromas Branch.)

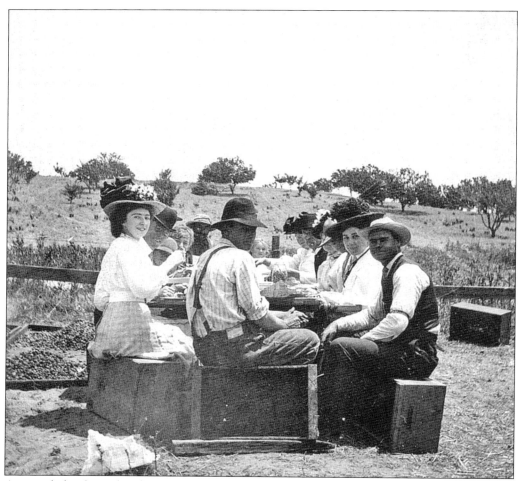

Aromas ladies bring lunch to the men who have been boxing apricot pits for shipment (notice the pits on the tray on the left). Albert Snyder recalled, "The pits were sold along with the dry fruit. They got money for the pits because I think there was something about the pit that they used in perfume at that time." An essential oil called persic oil is made from apricot pits. Elmer Snyder sits at the head of the table, and John Snyder is to his right. (Courtesy of the Monterey County Library, Aromas Branch.)

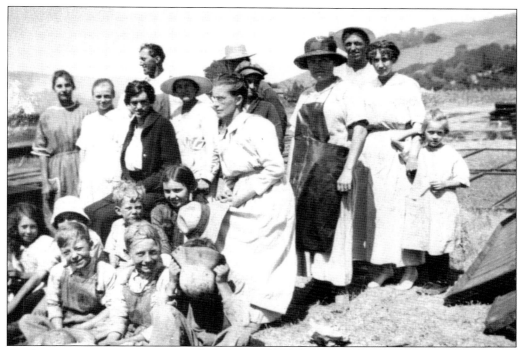

An Aromas apricot-pitting crew, including several children, poses for a photograph. Children as young as five joined their families in the pitting sheds. Four people filled each eight-foot by 35-inch redwood tray with apricots. First the fruit was cut in half and then laid face up. (Courtesy of the Monterey County Library, Aromas Branch.)

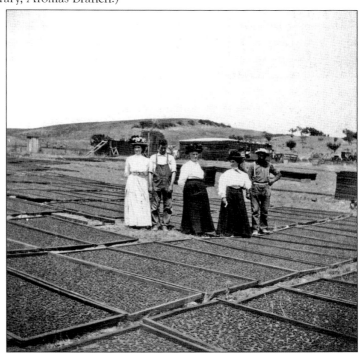

Trays of apricots dry in the sun at Elmer Snyder's dry yard at 570 Carpenteria Road. Apricots were first treated with sulphur for three to four hours in a sulphur house. The sulphur kept the apricots an appealing copper color; otherwise they would turn black when dried. (Courtesy of the Monterey County Library, Aromas Branch.)

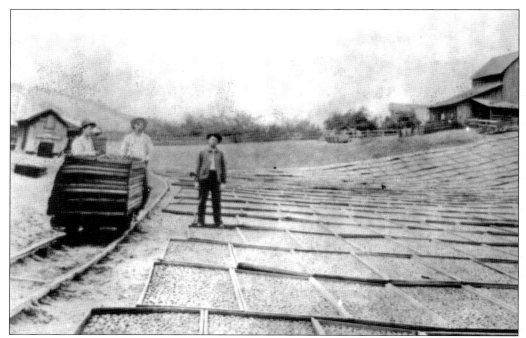

Pictured here is Chadwell's dry yard in the 1920s. Trays of fresh apricots were stacked six feet high on a small railcar and then run into the sulphur house (seen in the background). Each sulphur house was just large enough to hold one car. Some farmers had over 10 sulphur houses. (Courtesy of the Monterey County Library, Aromas Branch.)

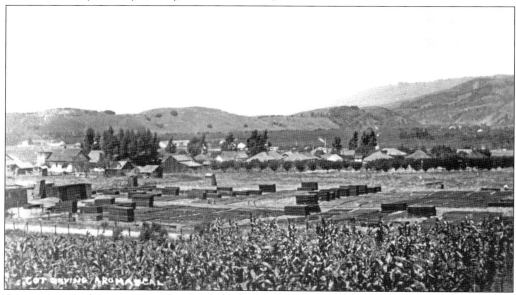

An orange sea of apricots was a familiar sight during the summer months in Aromas. Apricots dried in about one week. Juice collected in the center of each apricot, and Albert Snyder remembered, "It used to be kind of fun to dip your finger in there and lick it, but of course that ruined the shape of the apricot and if you got caught, you would catch hell." (Courtesy of the Monterey County Library, Aromas Branch.)

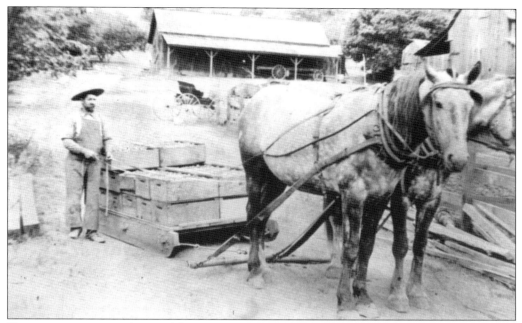

Horses were an integral part of the apricot operation. They hauled freshly picked fruit from the orchard to the pitting shed and once dried, they hauled packed fruit to the depot for shipment. Plowing and harrowing the orchards was done with horse-drawn equipment. (Courtesy of the Monterey County Library, Aromas Branch.)

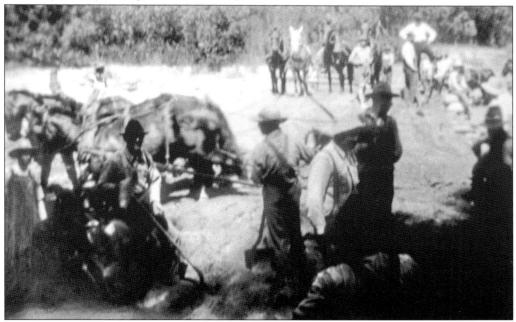

Aromas farmers move dirt to dam the Pajaro River on June 1, 1920. Every year, the river was dammed to create a swimming hole for local residents and visiting workers. After the first heavy winter rains, farmers knocked the dam down and the river resumed its natural flow. (Courtesy of the Monterey County Library, Aromas Branch.)

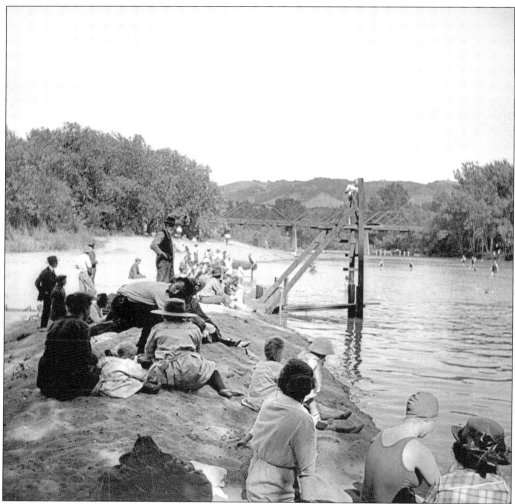

Albert Snyder recalled that all the kids in town learned to swim in the Pajaro River swimming hole. "It was just like a big party. And then at night there would always be somebody that could make a little music, and we had a big community bonfire and they would sit around there and sing." (Courtesy of the Monterey County Library, Aromas Branch.)

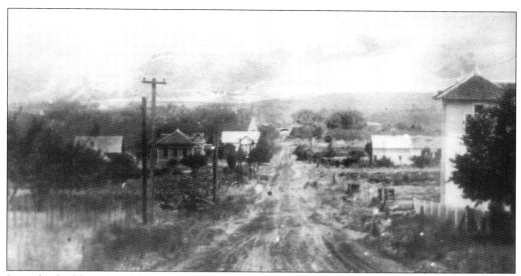

Just a few buildings lined Carpentaria Road at the beginning of the 19th century. The first structure on the left is the Slayton House, followed by the school and Baptist church. The Methodist church is seen in the right foreground. It was moved to the school property in the 1920s and later to 379 Blohm Avenue, where it was first used by the Aromas Fire Department and then as a garage. (Courtesy of the Monterey County Library, Aromas Branch.)

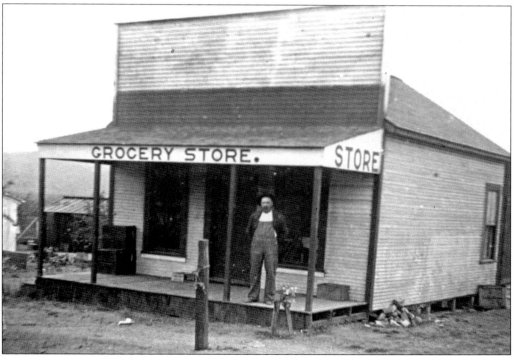

Cyrus Marshall stands on the porch of his grocery store in June 1909. In the 1930s, "Mick" Craig opened a pool hall here, but it was soon closed due to negative public opinion. Today Herrlich real estate occupies the building. (Courtesy of the Monterey County Library, Aromas Branch.)

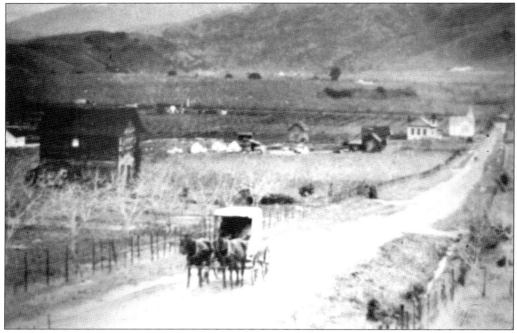

The Aromas hills are visible in the background as Homer Marshall's butcher wagon climbs up Carpenteria Road during the winter of 1900. The Kortright and Barber homes are visible across from the Baptist church and school. Aromas's original one-room school is visible at the center of Blohm Avenue. (Courtesy of the Monterey County Library, Aromas Branch.)

Albert Snyder sits in his father's 1912 Buick with his dog Carlo in the back seat. In the background is Kortright's store. Rosa Kortright served as postmistress from 1897 to 1914. In addition to operating the post office out of the store, William Kortright had a blacksmith shop out back. (Courtesy of the Monterey County Library, Aromas Branch.)

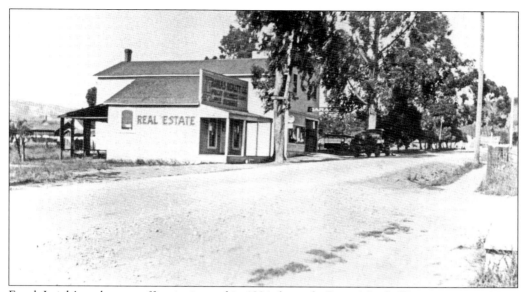

Frank Leigh's real estate office is pictured in 1924, formerly Cyrus Marshall's grocery store. Next door at the Yeomen's Hall, Al Wise operated a garage (the sign is barely visible through the trees). (Courtesy of the Monterey County Library, Aromas Branch.)

The Aromas Yeoman's Hall was built around 1905. The organization used the top floor for meetings, while the bottom floor was used as a grocery store. Note the water trough at the corner of the porch railing. (Courtesy of the Monterey County Library, Aromas Branch.)

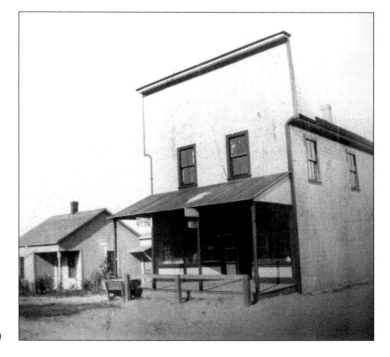

Mr. Ross, who operated a grocery store on the ground floor of the Yeoman's Hall, is dressed for a hobo party. He and his family lived in the rear of the store. In the 1930s, Mr. and Mrs. Fred Hubbard ran the store, followed by Mr. and Mrs. Dan White in the 1940s. Both the Whites and Hubbards lived on the second floor. (Courtesy of the Monterey County Library, Aromas Branch.)

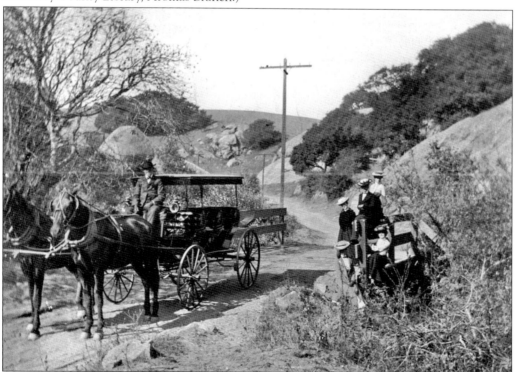

Looking up Carpenteria Road, the Bohnett's home can be seen in the foreground. It served as the county branch library from 1915 to 1920. Next door is the Harvey home on the corner of Viola Drive, and in the distance, Chadwell's apricot orchard blankets the hill. (Courtesy of the Monterey County Library, Aromas Branch.)

Aromas residents take a buggy ride along Cole Road near San Juan Rocks. Legend has it that two men who stole $10,000 were hung in the vicinity. The money was never recovered, and many believe they buried their loot close by. (Courtesy of the Monterey County Library, Aromas Branch.)

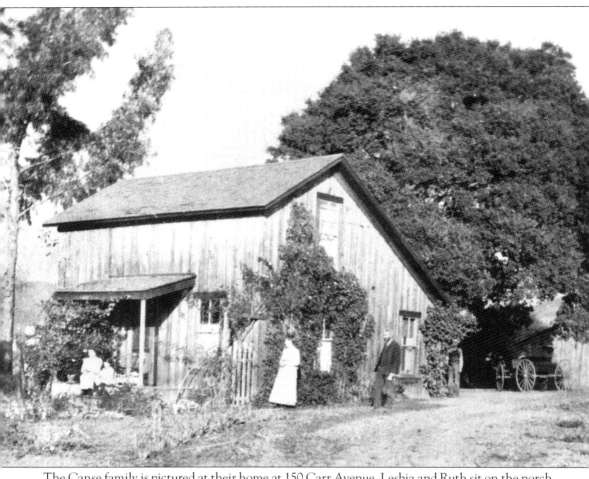

The Canse family is pictured at their home at 150 Carr Avenue. Lesbia and Ruth sit on the porch while Mr. and Mrs. Canse stand nearby. Brother Von is at the rear. William Canse served as postmaster from 1915 to 1924. He bought a lot for $200 at 368 Blohm Avenue and built a post office. (Courtesy of the Monterey County Library, Aromas Branch.)

After her father's death, Lesbia Canse was officially appointed postmistress for Aromas and served until July 1, 1956. (Courtesy of the Monterey County Library, Aromas Branch.)

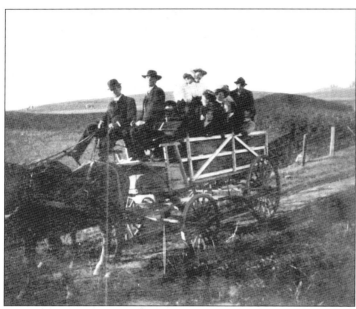

This group of merrymakers is near the Chittendon gate as they drive down Mount Pajaro into the Aromas Valley. The cheerful faces confirm one writer's opinion about Aromas: "It is seldom that one finds living conditions so nearly perfect as here. With good producing soil, a most equable climate and excellent social conditions, there is everything to make life worth living." (Courtesy of the Monterey County Library, Aromas Branch.)

Aromas pioneer Bill Fly admires his bumper crop of corn at 217 Carr Avenue. (Courtesy of the Monterey County Library, Aromas Branch.)

The Slaytons, who owned the corner of Blohm Avenue and Carpenteria Road, built a tennis court on the empty lot. This was followed by a basketball court, until vacant again, the lot was used by traveling circuses, carnivals, and revival meetings. In the 1920s, Melissa Gorham Chadwell, pictured next to her son Tracy, operated a service station on this corner. Next, a barbershop operated out of the building until Mose Hutchings bought the property in the 1940s. His wife transformed the lot into a park with the help of the Aromas Garden Club. (Courtesy of the Monterey County Library, Aromas Branch.)

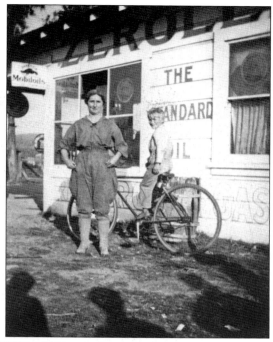

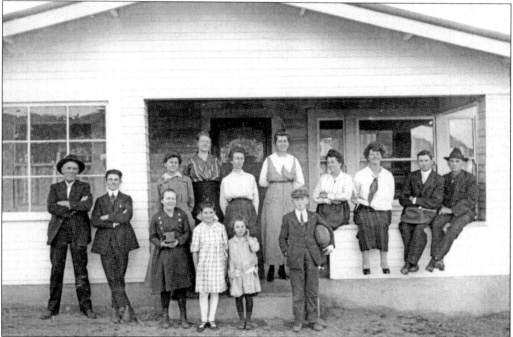

Bertha and Dick Hiatt hosted a house warming in their new home at 331 Carpenteria Road. The Hiatts ran a grocery store on Blohm Avenue. Pictured, from left to right, are (first row) Bert Meachem, Edgar Slayton, Bertha Hiatt, Mattie Smith, Florence Slayton, and Emro Smith; (second row) Mildred Smith, Edith Slayton, Mildred Meachem, Zora Meacham, Susie Slayton, Jean Blair, Dick Hiatt, and Harry Smith. (Courtesy of the Monterey County Library, Aromas Branch.)

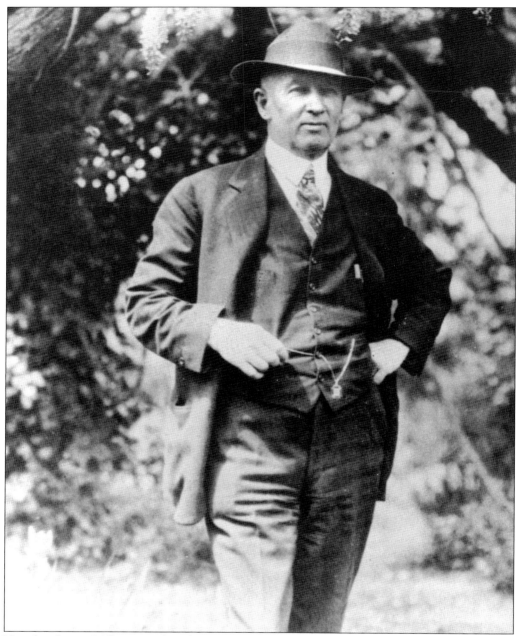

Noted architect William Weeks, whose architectural career was launched in Watsonville in the early 1890s, is pictured at his ranch in Aromas. Weeks was awarded successive contracts to build churches, homes, commercial buildings, and schools in the Monterey Bay region and Northern California. In the first 18 years of his practice, he designed and supervised the construction of over 1,000 buildings. (Courtesy of the Monterey County Library, Aromas Branch.)

Mrs. William Weeks (Maggie) and children Harold, Arthur (with teddy bear), and Margaret sit on a hillside at the family's Aromas ranch. The ranch had a swimming pool with separate children's pool, a croquet court, and dahlia garden. (Courtesy of the Monterey County Library, Aromas Branch.)

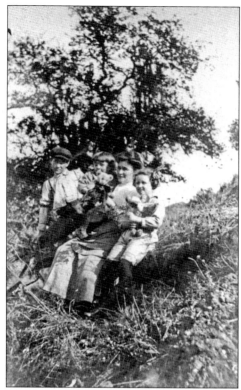

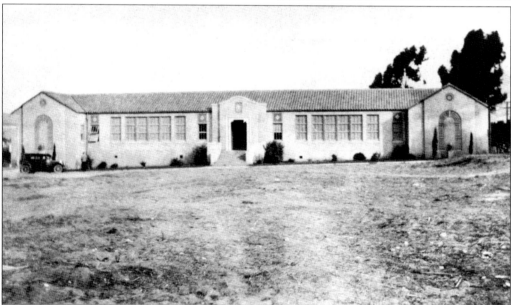

William Weeks was known throughout California for school design. He designed the Vega school in Aromas in 1925. It was in continuous use until 1950. Weeks utilized a simple Mediterranean style for the building and donated the original roof tile. (Courtesy of the Monterey County Library, Aromas Branch.)

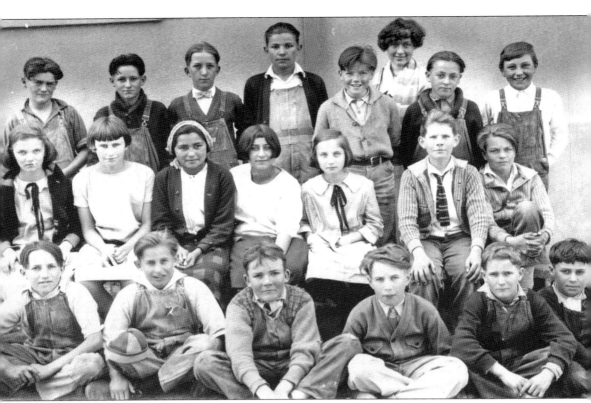

Students from Vega school's original fifth and sixth grades pose for their school photograph. Pictured, from left to right, are (first row) Harvey Stevens, Ernie Biddle, Chris Melinich, Ernest Staggi, Tracy Chadwell, and Manual Marcus; (second row) Edith Richardson, Beulah Kirkman, Bertha Carter, Rose Chiapareli, Jean Richardson, Howard Cottrell, and Sidney Hardy; (third row) K. Marshall, Norman Goodwin, Charles Bolla, Dan Ambulia, Brick Julian, Jimmy Goodwin, and Harold Miller; (fourth row) teacher Miss Alec. (Courtesy of the Monterey County Library, Aromas Branch.)

The Chadwell family is pictured, from left to right, as follows: (first row) Clifford, Emmarett (mother), Ira Lee, Harrison (father), and Ruby; (second row) Chester, Ed, Dayton, and Jasper. (Courtesy of the Monterey County Library, Aromas Branch.)

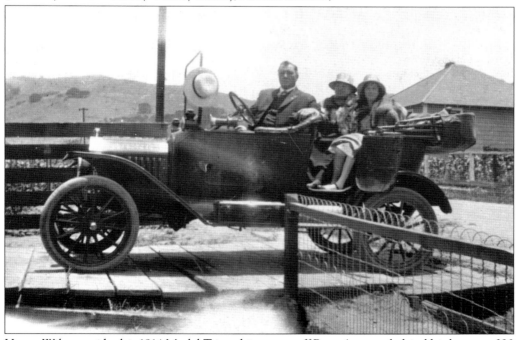

Henry Wilson guides his 1914 Model T into his garage off Rose Avenue, behind his home at 320 Carpenteria Road. In the back seat are Mrs. Wilson on the left and his niece. (Courtesy of the Monterey County Library, Aromas Branch.)

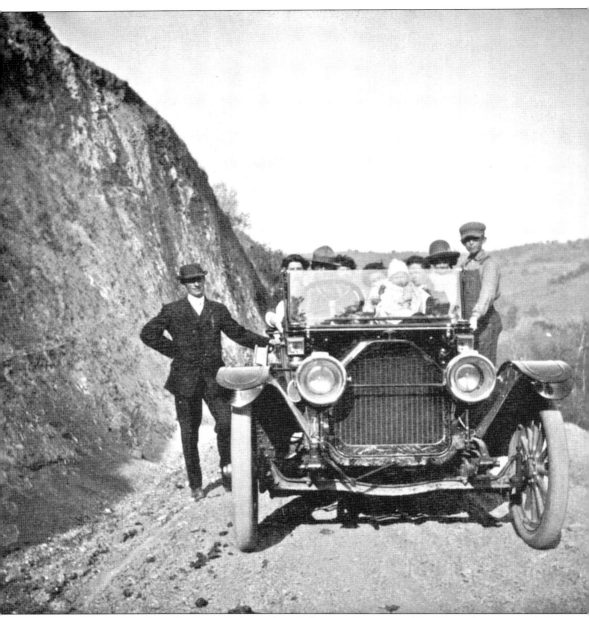

John Snyder's 1912 Buick is pictured on Chittendon Pass in 1913. The pass took its name from San Francisco lawyer N. W. Chittendon, who owned the land. He built extensive roads across his property. Upon his death in 1887, the land was surveyed into 20-acre lots and sold. In 1894, the county accepted the road as a public highway. (Courtesy of the Monterey County Library, Aromas Branch.)

A work crew rebuilds the Aromas Bridge after storm waters washed it away in 1912. (Courtesy of the Monterey County Library, Aromas Branch.)

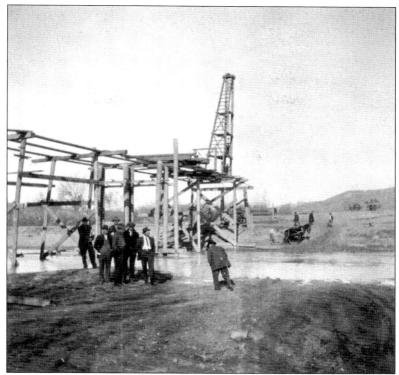

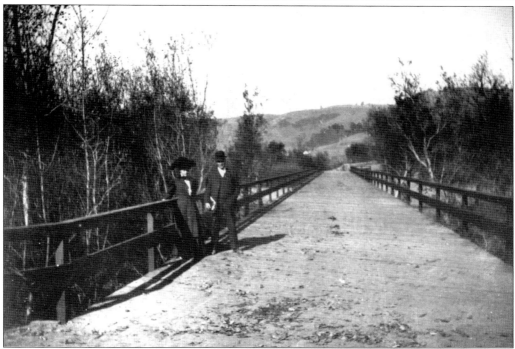

Mr. and Mrs. Frank Sproule stand on the newly constructed Aromas Bridge. (Courtesy of the Monterey County Library, Aromas Branch.)

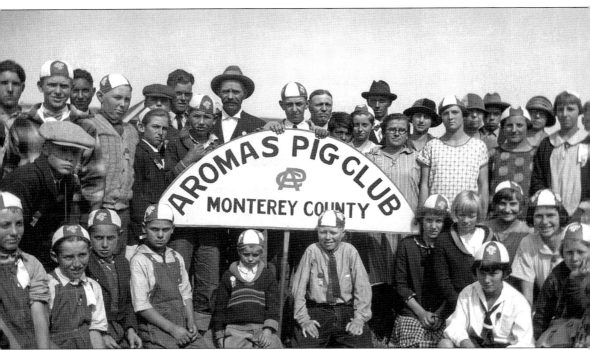

Today's 4-H Clubs were an outgrowth of Pig Clubs, organized to teach rural children about agriculture. County extension agents provided materials, and local parents volunteered as leaders. (Courtesy of the Monterey County Agricultural and Rural Life Museum.)

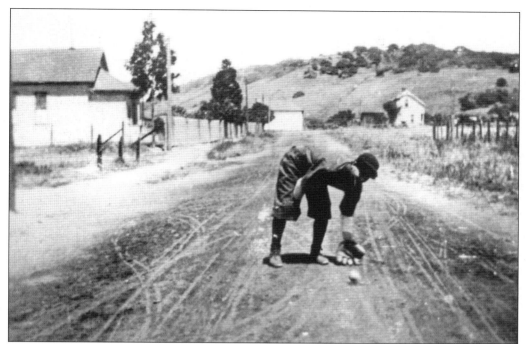

An Aromas baseball player reaches for a ground ball on Blohm Avenue. The building in the left foreground was the original schoolhouse. When the new school was built, Henry Blohm bought the building, moved it to Rose Avenue, and rented it. (Courtesy of the Monterey County Library, Aromas Branch.)

Baseball players entertain onlookers on a lazy afternoon in Aromas. A Chinese apple dryer building is visible in the background. (Courtesy of the Monterey County Library, Aromas Branch.)

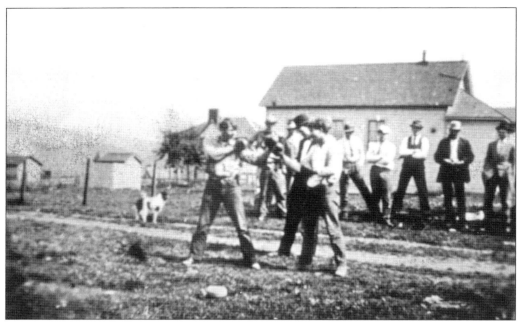

In 1910, young pugilists take a few swings next to the old Aromas school on Blohm Avenue, across from the Birdsey store (now the location of Ducky Deli). (Courtesy of the Monterey County Library, Aromas Branch.)

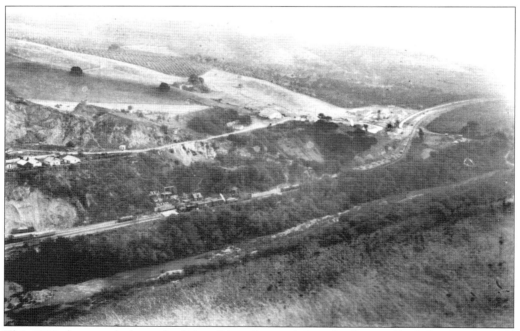

This 1926 photograph shows the Pajaro River flowing below the Granite Rock Quarry. Directly above the river are the Southern Pacific Railroad tracks and Granite Rock trucks. Above these are the quarry operations and some of the houses that were rented to quarry workers. (Courtesy of the Monterey County Library, Aromas Branch.)

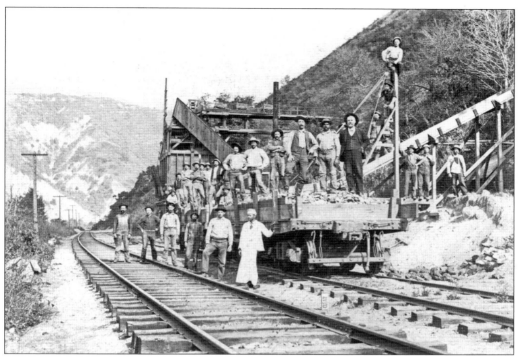

Pictured between 1900 and 1906 is the crew at the Granite Rock Company's Logan Quarry, near Aromas. Arthur R. Wilson, dressed in the suit to the far right, purchased the foreclosed granite quarry with five other investors in 1900. Early on, rock was hauled on flat cars with sideboards, seen here. (Courtesy of the Monterey County Library, Aromas Branch.)

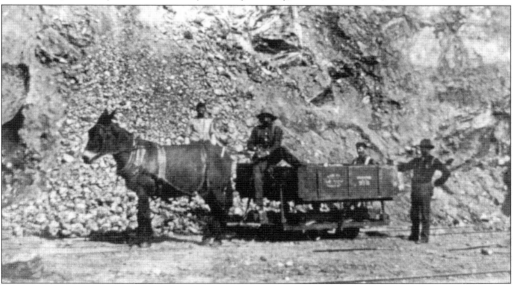

A job at the quarry was hard, backbreaking work. Using sledgehammers, picks, and shovels, 15 men labored to break up the rock and wheelbarrow it to mule-drawn wagons. The mules hauled their loads to the railroad line for shipment. In 1911, a locomotive replaced the hard-working mules. (Courtesy of the Monterey County Library, Aromas Branch.)

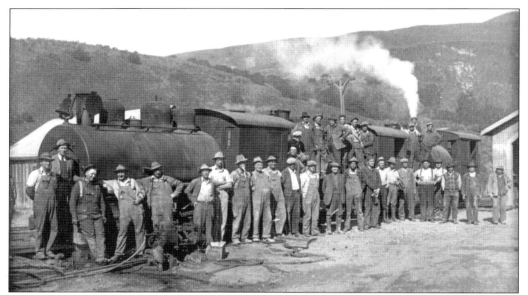

Quarry crews worked 10-hour days for $1.75 an hour to produce 175 tons of crushed rock per day. They slept in the company bunkhouse and ate at the cookhouse. In 1903, the quarry began to modernize with steam-driven, automated rock-crushing equipment that could produce 20 tons of crushed rock per hour. (Courtesy of the Monterey County Library, Aromas Branch.)

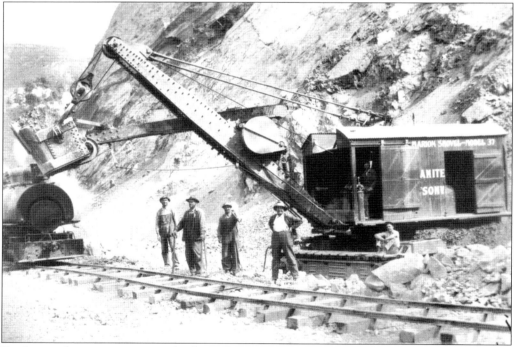

Further mechanization came in the form of a Marion steam shovel, purchased in 1909. It was used to load rock into railcars, as seen here. Men then broke up the big rocks with sledgehammers. If a rock did not break, it was pushed off the car to be dynamited by the powder crew. (Courtesy of the Monterey County Library, Aromas Branch.)

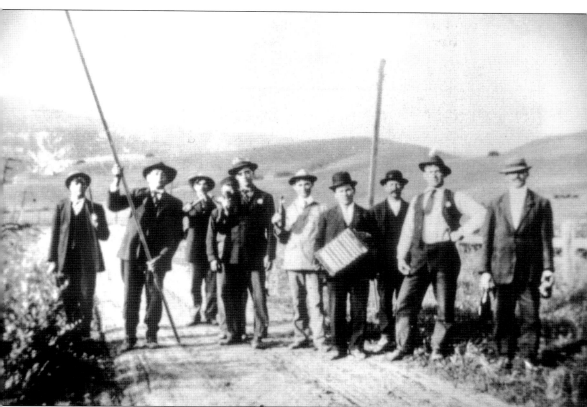

Yugoslavs march down Quarry Road waving their country's new flag. In 1918, the southern Slav peoples were united into a common state—the Kingdom of Serbs, Croats, and Slovenes. Slavs from the Dalmatian coast were early pioneers of the Pajaro Valley's apple industry. (Courtesy of the Monterey County Library, Aromas Branch.)

ACROSS AMERICA, PEOPLE ARE DISCOVERING SOMETHING WONDERFUL. *THEIR HERITAGE.*

Arcadia Publishing is the leading local history publisher in the United States. With more than 3,000 titles in print and hundreds of new titles released every year, Arcadia has extensive specialized experience chronicling the history of communities and celebrating America's hidden stories, bringing to life the people, places, and events from the past. To discover the history of other communities across the nation, please visit:

www.arcadiapublishing.com

Customized search tools allow you to find regional history books about the town where you grew up, the cities where your friends and family live, the town where your parents met, or even that retirement spot you've been dreaming about.